PIERRE ET GILLES

SAILORS & SEA

To stay informed about upcoming TASCHEN titles,
please request our magazine at www.taschen.com/magazine
or write to TASCHEN, Hohenzollernring 53, D–50672 Cologne,
Germany, contact@taschen.com, Fax: +49-221-254919.
We will be happy to send you a free copy of our magazine
which is filled with information about all of our books.

INTRODUCTION: Éric Troncy, Dijon
DESIGN: Philippe Morillon, Paris

ENGLISH TRANSLATION: Chris Miller, Oxford
GERMAN TRANSLATION: Uta Grosenick, Cologne

EDITORIAL COORDINATION: Simone Philippi, Cologne
PRODUCTION-COORDINATION: Tina Ciborowius, Cologne

Printed in China

ISBN 978-3-8365-0885-8

PIERRE ET
GILLES

SAILORS & SEA

TASCHEN

HONG KONG KÖLN LONDON LOS ANGELES MADRID PARIS TOKYO

A Port of Call in the Work of Pierre et Gilles

by Éric Troncy

"Farewell, O sailors, you simple-hearted votaries of the wind."

Jean Cocteau, "L'Adieu aux fusiliers marins", in *Discours du grand sommeil*, 1920

The earliest work of Pierre et Gilles dates from nearly thirty years ago, but there has been no radical stylistic change over that period. This fact is of interest in itself. The solitary exception might be the recently revealed *Exils intérieurs* (Internal Exiles) series, which sees the artists investing a territory by no means abstract but less directly narrative and figurative. Their formal strategies seemed to have attained a natural fixity in the seventies, one that the key image *Adam et Ève* (Adam and Eve, 1981) could only confirm. The same is true of their serenely immutable technique: Pierre takes photographs on which Gilles paints. The spread of information technology has not had the slightest effect on this body of work traditionally remote from the facilities of digital retouching or the forms of duplication afforded by the computer. Steadily, without haste, new images follow upon the old, forming a corpus stylistically and formally homogeneous. No question for them of a 'pink period' giving way to a 'blue'.

Nor can we trace within this continuity a succession of different subjects, each exercising upon the imagination its own seductions or compulsions and deriving from some arbitrary decision. No, their sophisticated and complex powers of imagination are inscribed upon broad and timeless themes often intimately interwoven—love, death, mythology and religion. The images in which they issue are 'snaps' (incongruous word) of their long-meditated and meticulously constructed sets. So it is no surprise to find that the sea has a central role in their art, a role at once unique and preponderant in that it encapsulates the romantic potential of their themes. An extravagant population of sailors moves through their images old and new. *Le marin* (The Sailor, 1977), protagonist of their first work, has made regular appearances ever since. He is foregrounded in *Le marin rêveur* (Dreaming Sailor, 1994), *Le capitaine et son petit mousse* (The Captain and His Little Ship's Boy, 1995), *Le petit matelot* (Little Seaman, 1997) and the ensemble piece *La rose et le couteau* (Rose and Knife, 1998); he is glimpsed in *Le pêcheur de perles* (Pearl Fisher, 1992) and *La sirène et le marin* (Siren and Sailor, 1997); and he is implied by a second motif, that of the starfish as in *Le ciel, les étoiles et la mer* (Sky, Stars and Sea, 1997), *Vénus marine* (Marine Venus, 2000) and *Presque rien* (Next to Nothing, 2000).

Travel souvenirs paradoxically predate the imaginary voyage they evoke. In the same way the images of Pierre et Gilles empower the spectator to set him- or herself adrift on the currents of dream. No compass is used on this voyage, only recurrent images drawn from privileged sources: from Jean Genet's *Querelle de Brest*—and its film adaptation by Rainer Werner Fassbinder (1982)—and from *Twenty Thousand Leagues under the Sea* by Jules Verne. The latter inspired one of their most recent images, *Capitaine Nemo* (Captain Nemo, 2004), with its overtones of the submarine *Nautilus*. Roland Barthes tells us: "...the ship may well

be a symbol for departure; it is, at a deeper level, the emblem of closure. An inclination for ships always means the joy of perfectly enclosing oneself, of having at hand the greatest possible number of objects..." He continues: "The *Nautilus*, in this respect, is the most desirable of all caves: the enjoyment of being enclosed reaches its paroxysm when, from the bosom of this unbroken inwardness, it is possible to watch, through a large window-pane, the outside vagueness of the waters, and thus define, in a single act, the inside by means of its opposite."[1]

The images of Pierre et Gilles are made in the basement studio of their house, attaining physical life within the confines of the space in which their subject poses. The bathyscaph elucidated by Barthes offers an uncanny metaphor of this subject: surrounded by a host of carefully constructed iconographic elements, the model is confined within an *interior* that *a contrario* defines the *external* world.

The sailor must, like the spectator, be ready for adventure, ready to sail around the world: to discover new and unknown lands that may savour of paradise. (In the work of Pierre et Gilles there are many repre-sentations of Eden.) He must contemplate with a steady eye the possibility of shipwreck (as Pierre et Gilles do in the 1968 series of that name) and the random physicality of encounters in the port of call (*Jolis voyous* 'Pretty Thugs' series, 1995–96). This is a theatre not merely of cruelty but of liberation: the life of the mariner combines resignation and nostalgia for what he has left behind with the promise of what he may discover at the term of his voyage. His solitude is peopled with unexpected creatures in whom beauty and cruelty also combine, like the Marlene Dietrich of *The Blue Angel* who features in *Au bar de la marine* (Navy Bar, 2001).

A further clear function of the sailor in the work of Pierre et Gilles is thus as a reflection of the specta-tor, who must give him- or herself up to the apprecia-

tion of the work of art without any guarantee of destination or any certainty that the distant shore will ever be reached, travelling with a simple conviction—that the voyage itself is the goal.

[1] Roland Barthes, *Mythologies*, translated by Annette Lavers, Paladin, London, 1973.

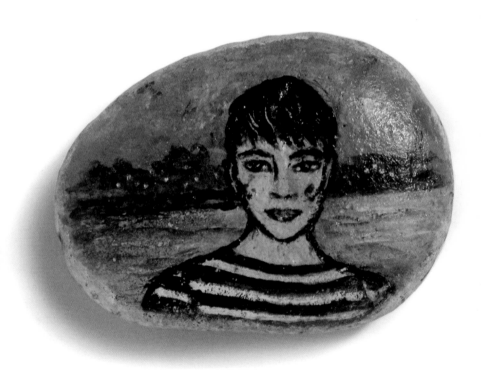

Pierre: **Pierre**, galet peint, 2001

Ein kurzes Anlegen an Land im Werk von Pierre et Gilles

von Éric Troncy

„Adieu Matrosen, ihr unbefangenen Anbeter des Windes."

Jean Cocteau, „L'adieu aux fusiliers marins", *Discours du grand sommeil*, 1920.

Das Werk von Pierre et Gilles hat seit den ersten Arbeiten vor fast dreißig Jahren keine größere formale Revolution durchlaufen. Eine Ausnahme sind vielleicht die jüngst entstandenen *Exils intérieurs* (Innere Exile), die den Betrachter auf ein wenn auch nicht gerade abstrakteres, so doch weniger narratives und figuratives Gebiet führen. Seit Ende der siebziger Jahre (und stärker ab 1981, als das Schlüsselbild *Adam et Eve* entstand) sind die Strategien ihres bildnerischen Vokabulars und die Modalitäten der technischen Ausführung festgelegt, gewissermaßen in einer immer währenden Unabänderlichkeit fixiert: Pierre fotografiert, und Gilles malt auf die Fotografien. Der zunehmende Einsatz digitaler Bildbearbeitung hat auf ihr Werk keinen Einfluss, das aus Tradition weit entfernt ist von den Annehmlichkeiten sowohl der elektronischen Bildbearbeitung als auch der technischen Reproduzierbarkeit, wie sie der Computer möglich macht: In gewollt langsamer Abfolge reihen sich neu produzierte Bilder an

ihre Vorgänger und ergeben ein bildnerisch homogenes und stilistisch kohärentes Pantheon. In ihm gibt es keine „rosa" und auch keine „blaue" Periode.

Diese Form von Beständigkeit wird auch nicht durchbrochen durch eine plötzliche Änderung der Inhalte und Sujets, von denen eines auf das andere folgt und die Phantasie des Betrachters zufällig und ungezwungen in diese oder jene Richtung schweifen lässt oder mit Macht entführt. Diese komplexe Imaginationskraft der beiden Künstler, von der jedes ihrer Bilder quasi ein „Schnappschuss" ist (das Wort ist hier ziemlich unpassend, weil jedes Bild das Ergebnis einer langwierigen Inszenierung ist, die genauestens und reiflich überlegt wurde), kommt bei den großen generischen und zeitlosen Themen zum Ausdruck, die oftmals unauflösbar miteinander verbunden dargestellt werden: die Liebe, der Tod, die Mythologie, die Religion. In dieser Hinsicht ist es nachvollziehbar, dass das Meer im Werk von Pierre et Gilles eine einzigartige und zentrale Rolle spielt, in der das romantische Potenzial der Künstler besonders zur Geltung kommt. Tatsache ist, dass man sowohl in den älteren wie auch jüngeren Arbeiten ungewöhnlich häufig Matrosen antrifft, wie in *Le marin* (Der Matrose, 1977), bald gefolgt von einer Reihe weiterer maritimer Anspielungen, direkt wie bei *Le marin rêveur* (Der träumende Matrose, 1994); *Le capitaine et son petit mousse* (Der Kapitän und sein kleiner Schiffsjunge, 1995); *Le petit matelot* (Der kleine Seemann, 1997); die Gruppe *La rose et le couteau* (Die Rose und das Messer, 1998); oder indirekt wie bei *Le pêcheur de perles* (Der Perlentaucher, 1992) oder *La sirène et le marin* (Die Sirene und der Matrose, 1997). Hinzu kommen die unzähligen Arbeiten mit dem Motiv des Sternenhimmels über dem Meer: *Le ciel, les étoiles et la mer* (Der Himmel, die Sterne und das Meer, 1997); *Vénus marine* (Venus der Seeleute, 2000), *Presque rien* (Fast nichts, 2000).

Die Bilder von Pierre et Gilles sind so etwas wie „Reiseerinnerungen", die paradoxerweise schon vor der Einschiffung in ihrer Gedankenwelt existiert haben: Sie sind Fortbewegungsmittel, deren sich der Betrachter bedienen kann, um in seine Träume zu reisen. Der Ausflug erfolgt ohne Kompass, denn der, zu dem Pierre et Gilles einladen, vollzieht sich in den Bildern und wird angeregt von Motiven, zu denen sie eine ganz besondere Beziehung haben. Von *Querelle de Brest* von Jean Genet und seiner filmischen Umsetzung durch Rainer Werner Fassbinder im Jahr 1982 bis zu 20.000 *Meilen unter dem Meer* von Jules Verne, das die Inspiration für eines ihrer neuesten Bilder, *Capitaine Nemo* (Kapitän Nemo, 2004), war und die Nautilus heraufbeschwört, über die Roland Barthes schreibt: „Das Schiff kann zwar Symbol des Aufbruchs sein, aber es ist auf noch tiefere Weise Chiffre der Einschließung. Sinn für das Schiff ist immer die Freude, sich vollkommen einzuschließen, die größtmögliche Anzahl von Objekten zur Verfügung zu haben, über einen absolut begrenzten Raum zu verfügen." Danach führt er aus: „Die Nautilus ist die ideale Höhle, und das Genießen der Abgeschlossenheit erreicht dann seinen Höhepunkt, wenn es möglich ist, aus dem Schoß dieses nahtlosen Inneren durch eine große Scheibe das unbestimmte Außen des Wassers zu sehen und damit durch ein und dieselbe Bewegung das Innere durch sein Gegenteil zu bestimmen."[1]

Immer in den eigenen vier Wänden produziert, nehmen die Bilder von Pierre et Gilles zum ersten Mal in einem kleinen Atelier, das sich im Untergeschoss ihres Hauses befindet und in dem das Sujet posiert, physische Gestalt an. Für dieses Studio ist die Taucherkugel – wie sie von Barthes beschrieben wird – eine auf eigentümliche Weise zutreffende Metapher: Umgeben von einer Menge sorgfältig angeordneter, den Inhalt des Bildes bestimmender Requisiten, ist das Modell in einem „Innenraum" eingeschlossen, der

aber das Gegenteil, nämlich die „Außenwelt", verkörpern soll.

Wie der Betrachter muss der Matrose zum Wagnis, zur großen Fahrt bereit sein. Auf der Suche nach neuen, unbekannten Ländern, die vielleicht ein zweites Paradies sind (in den Arbeiten von Pierre et Gilles gibt es zahlreiche Darstellungen des Gartens Eden), muss er vorbereitet sein auf den Schiffbruch (Serie der *Naufragés* [Schiffbrüchige], 1986) oder auf unvorhergesehene muskulöse Begegnungen beim Anlegen (Serie *Jolis voyous* [Hübsche Taugenichtse], 1995/96). Das Meer ist der Schauplatz von Ungezügeltheit und Befreiung, auch wenn die Lebensumstände eines Matrosen Entsagung und Heimweh nach demjenigen bedeuten, den er bei der Abfahrt mit dem vagen Versprechen auf ein Wiedersehen am Ende der Reise zurücklassen muss: Die Einsamkeit dort wird bereichert durch die Begegnung mit unerwarteten Geschöpfen, die auch die Schönheit und Wildheit in sich tragen – der Marlene Dietrich aus dem Film *Der blaue Engel*, die man in *Au bar de la marine* (Zur Bar der Seeleute, 2001) trifft.

Der Matrose funktioniert also in den Arbeiten von Pierre et Gilles ganz eindeutig auch als ein Appell an den Betrachter, sich ohne Absicherung der Lust am Kunstwerk hinzugeben, ohne Gewissheit, in welche Richtung die Reise geht, ohne Garantie dafür, dass der angesteuerte Hafen auch wirklich erreicht wird, aber mit der festen Überzeugung, dass sich das Abenteuer lohnt.

[1] Roland Barthes, *Mythen des Alltags*, Suhrkamp, Frankfurt am Main, 1964.

Une courte escale à terre dans l'œuvre de Pierre et Gilles

par Éric Troncy

« *Adieu, marins, naïfs adorateurs du vent.* »

Jean Cocteau, « L'adieu aux fusiliers marins »,
Discours du grand sommeil, 1920

Depuis son origine il y a bientôt trente ans, l'œuvre
de Pierre et Gilles a cette singularité de n'avoir pas
accusé de révolution stylistique majeure – à l'excep-
tion, peut-être, des *Exils intérieurs* dévoilés récemment
et qui l'entraînent sur des territoires sinon plus ab-
straits, en tout cas moins immédiatement narratifs et
figuratifs. Dès la fin des années soixante-dix (et plus
encore à partir de 1981 et de l'image-charnière *Adam
et Ève*), les stratégies de leur vocabulaire plastique
étaient comme naturellement fixées, de même que les
modalités de son exécution technique, elle aussi figée
dans une forme sereine d'immuabilité : Pierre photo-
graphie et Gilles peint sur les photographies. La po-
pularisation de l'outil informatique n'a eu aucun effet
sur cette œuvre par tradition éloignée à la fois des
commodités de la retouche numérique et de la pos-
sible duplication autorisée par l'ordinateur : à un rythme
volontairement lent les images produites s'ajoutent
aux précédentes, formant un panthéon plastiquement

homogène et stylistiquement cohérent. Pas plus de « période rose », en somme, que de « période bleue ».

Cette forme de permanence n'a pas non plus été scandée par l'exploitation de sujets précis qui se seraient succédé les uns aux autres, entraînant ou contraignant l'imaginaire dans telle ou telle direction au gré d'une décision arbitraire. Cet imaginaire sophistiqué et complexe, dont chaque image produit une sorte « d'instantané » (le mot est d'autant plus incongru que chaque image fait l'objet d'une mise en scène fastidieuse, précise et mûrement réfléchie), s'articule autour de grands thèmes génériques et atemporels, souvent combinés ensembles et inextricablement liés : l'amour, la mort, la mythologie, la religion. À cet égard, c'est naturellement que la mer y joue, de manière unique et prépondérante, un rôle central, en ceci qu'elle cristallise leur potentiel romanesque. De fait, on retrouve dans des images tout aussi bien anciennes que récentes une extravagante population de marins, qui apparaît dès l'origine de leur travail dans *Le marin* (1977), bientôt suivie d'un chapelet d'occurrences directes (*Le marin rêveur*, 1994 ; *Le capitaine et son petit mousse*, 1995 ; *Le petit matelot*, 1997 ; ou l'ensemble *La rose et le couteau*, 1998) ou indirectes (*Le pêcheur de perles*, 1992 ; *La sirène et le marin*, 1997) sans compter le motif récurrent des étoiles de mer (*Le ciel, les étoiles et la mer*, 1997 ; *Vénus marine*, 2000 ; *Presque rien*, 2000).

Les images de Pierre et Gilles fonctionnent comme des « souvenirs de voyage », paradoxalement préexistant à une embarcation dans leur imaginaire : ce sont des véhicules que le spectateur emprunte pour s'abandonner à une dérive onirique. La dérive se conçoit sans boussole : celle à laquelle invitent Pierre et Gilles s'appuie sur les images produites par d'autres imaginaires avec lesquels elle entretient des rapports privilégiés. Du *Querelle de Brest* de Jean Genet et de son adaptation par Rainer Werner Fassbinder en 1982,

au *Vingt milles lieues sous les mers* de Jules Verne, qui donnera lieu à l'une de leurs plus récentes images : *Capitaine Nemo* (2004), une évocation du Nautilus à propos duquel Roland Barthes écrivait : « *Le bateau peut bien être symbole du départ ; il est, plus profondément, chiffre de la clôture. Le goût du navire est toujours joie de s'enfermer parfaitement, de tenir sous sa main le plus grand nombre possible d'objets.* » Ajoutant ensuite : « *Le Nautilus est à cet égard la caverne adorable : la jouissance de l'enfermement atteint son paroxysme lorsque, du sein de cette intériorité sans fissure, il est possible de voir par une grande vitre le vague extérieur des eaux, et de définir ainsi dans un même geste l'intérieur par son contraire.*[1] »

Toujours réalisées chez eux, dans l'atelier situé au sous-sol de leur habitation, les images de Pierre et Gilles prennent vie tout d'abord physiquement dans un petit espace où pose le sujet, dont le bathyscaphe éclairé par Barthes est une étrange métaphore : entouré d'une ribambelle d'éléments iconographiques soigneusement agencés, le modèle y est enfermé dans un *intérieur* qui désigne par son contraire le monde *extérieur*.

Comme le spectateur, le marin doit être prêt à l'aventure, au périple. À la découverte de terres nouvelles, inconnues, paradisiaques peut-être (il y a dans l'œuvre de Pierre et Gilles de nombreuses représentations de l'Éden), il doit être prêt à l'hypothèse du naufrage (ensemble d'images des *Naufragés*, 1986) ou aux rencontres fortuites et musclées des escales (ensemble d'images *Jolis Voyous*, 1995–96). Théâtre de la cruauté comme de l'affranchissement, la condition du marin cumule la résignation et la nostalgie de ce qui a été abandonné avant le départ et la promesse éventuelle de ce qui sera rencontré au fil du voyage : la solitude s'y peuple de créatures inattendues mêlant elles aussi beauté et cruauté – la Marlène Dietrich de *L'Ange Bleu*, rencontrée *Au bar de la marine*, 2001.

Le marin fonctionne ainsi très clairement dans leur œuvre aussi comme une évocation du spectateur qui doit s'abandonner sans certitude à l'appréciation de l'œuvre d'art, sans garantie de destination, sans certitude qu'un rivage envisagé sera effectivement atteint, mais avec la conviction que le voyage en vaut la peine.

[1] Roland Barthes, *Mythologies*, éditions du Seuil, Paris, 1957.

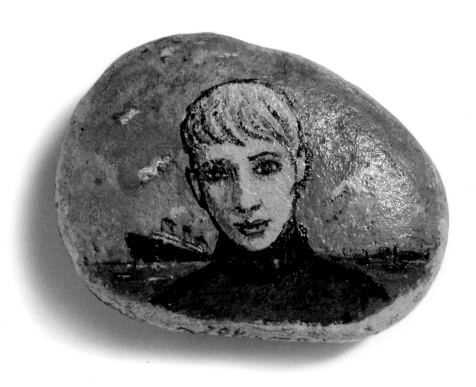

Pierre: **Gilles**, galet peint, 2005

Le marin, Philippe, 1985

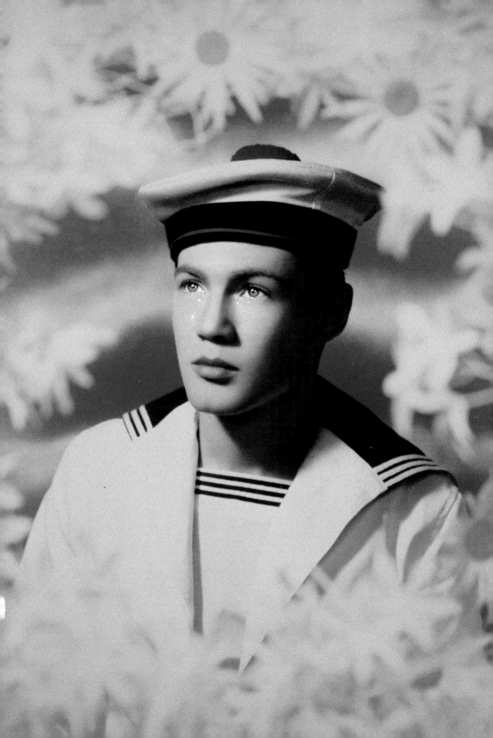

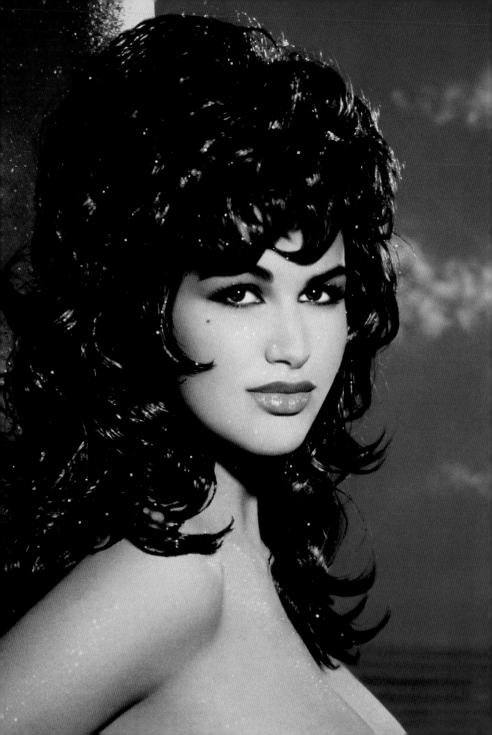

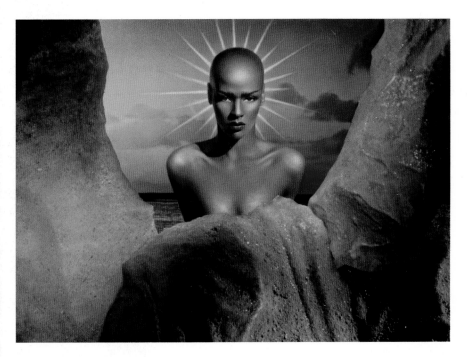

Funky Junky, Carole Miles, 1979

Helena, Helena Nogueirra, 1991

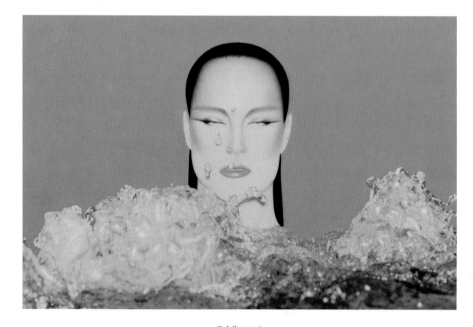

Zuleika, 1978

King sauna, Saïd, 1984

Following pages: **Les poissons,** 1985

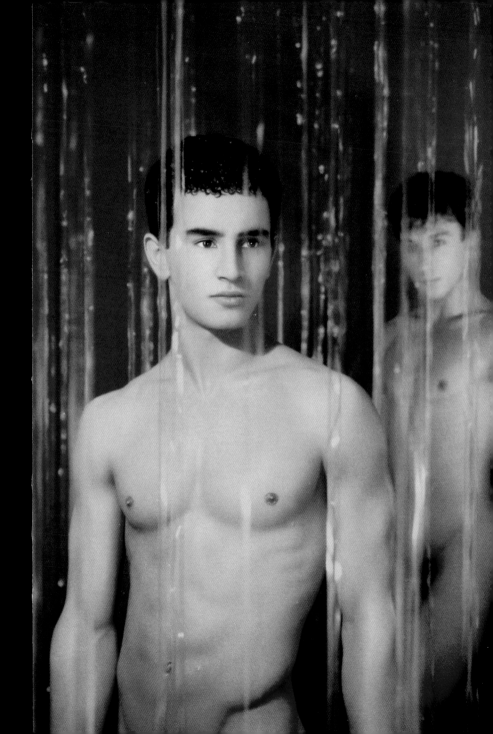

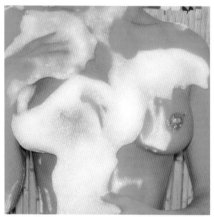

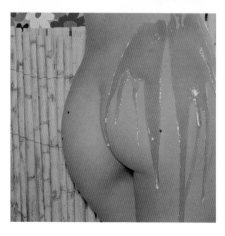

Bambou, 1978

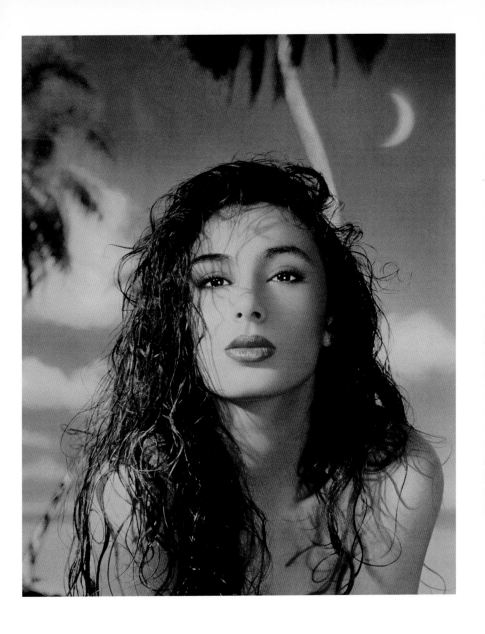

Salade de fruits, La p'tite Fred, 1982

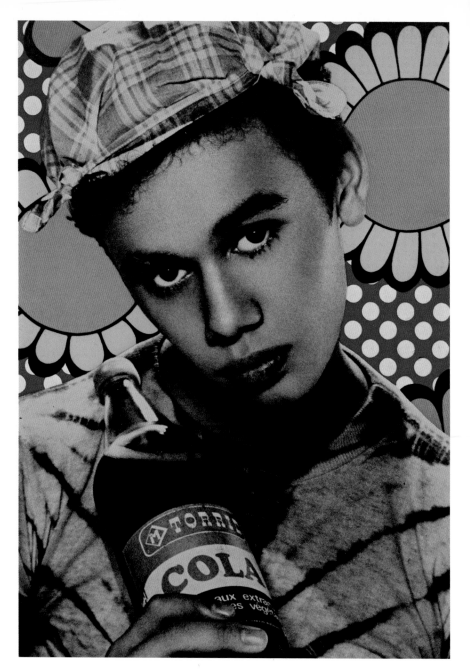

Les fonds à fleurs, Christian Louboutin, 1979

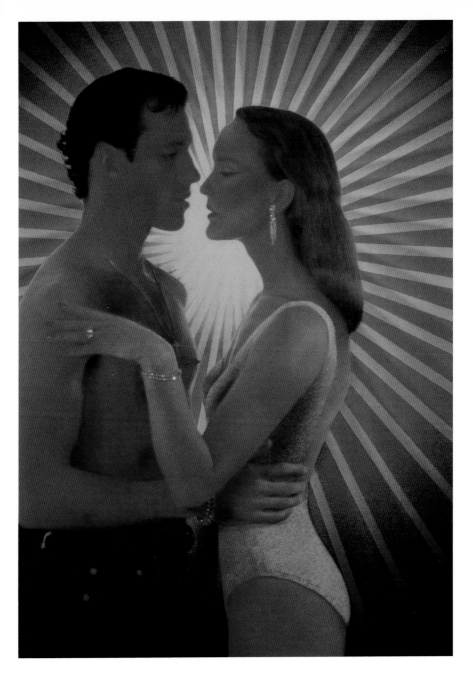

Sunset, Fred Suza et Zuleika, 1978

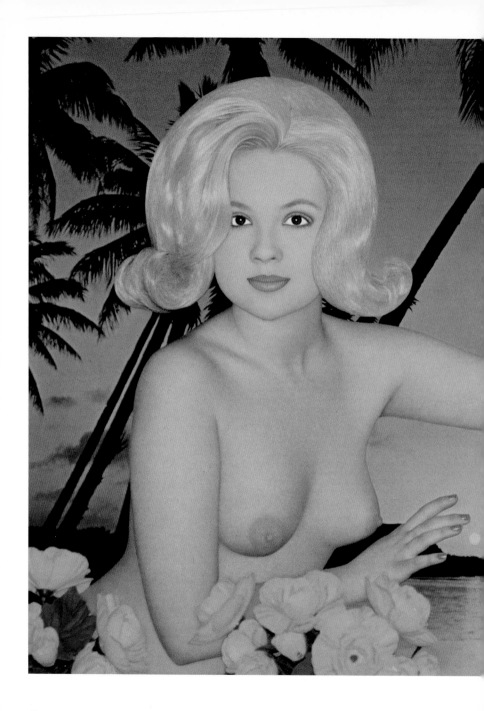

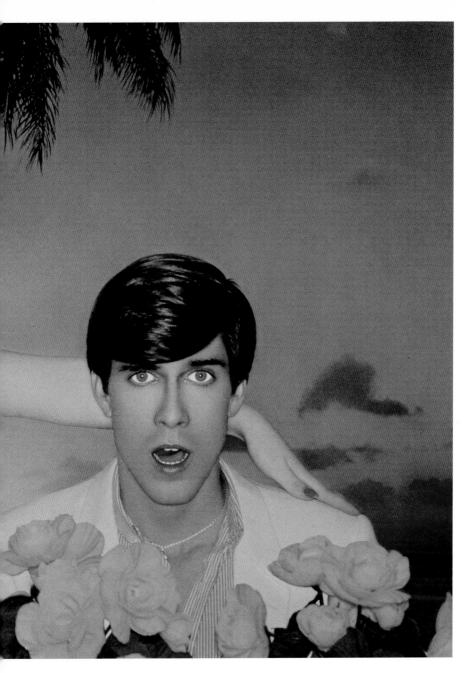

La drague à Los Angeles, Eva Ionesco et Tom Cashin, 1981

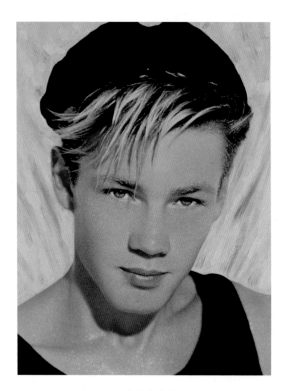

Les garçons de Paris, Philippe, 1983

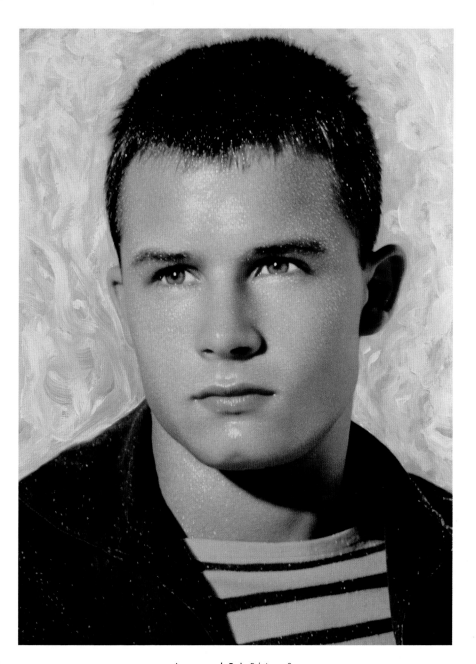

Les garçons de Paris, Fabrice, 1983

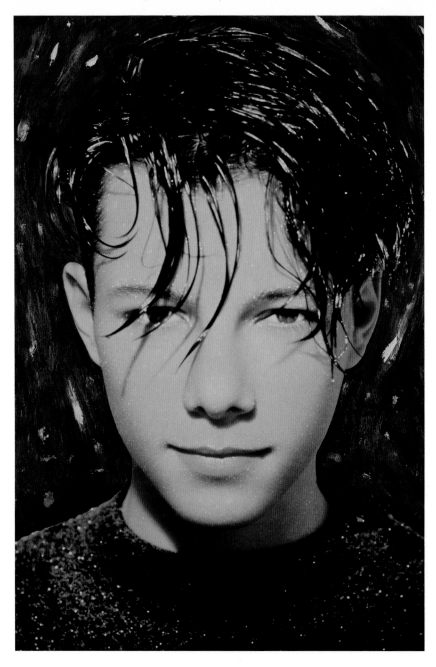

Les garçons de Paris, François, 1983

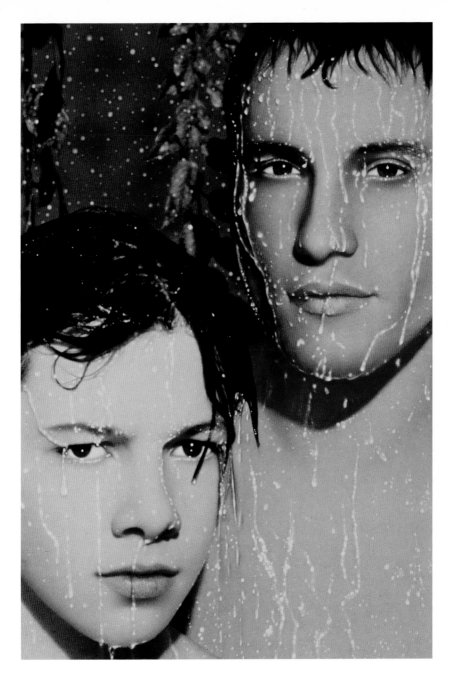

L'orage, David et François, 1983

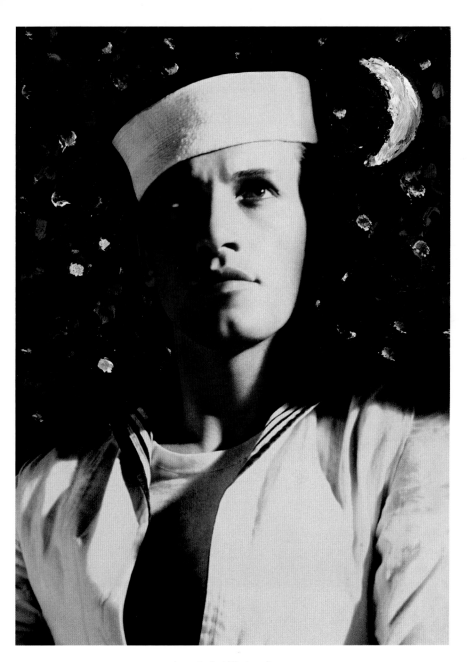

Le marin, David Pontremoli, 1977

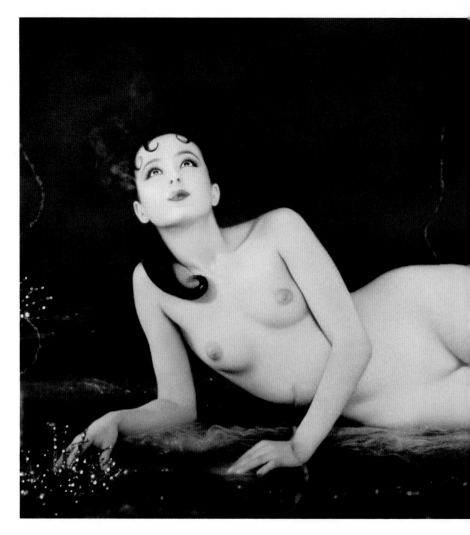

Pascaline, Pascale Lafay, 1984

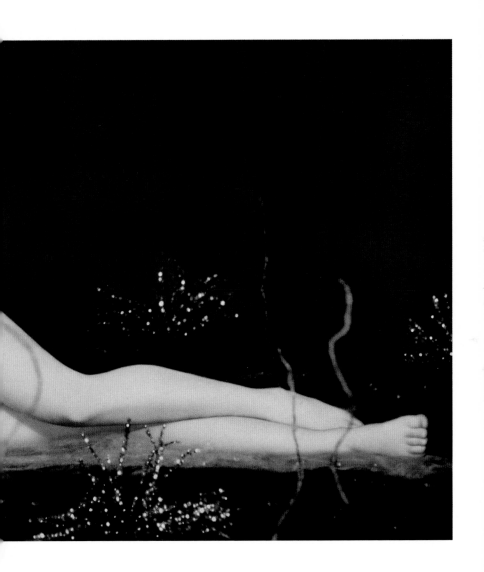

Following pages: **La poupée noyée**, 1985

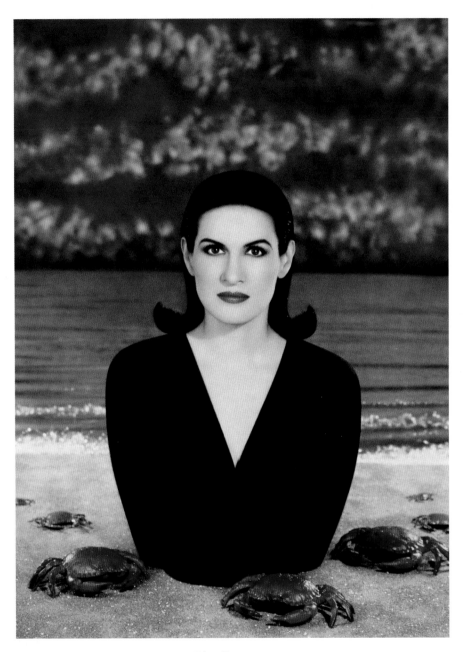

Paloma Picasso, 1990

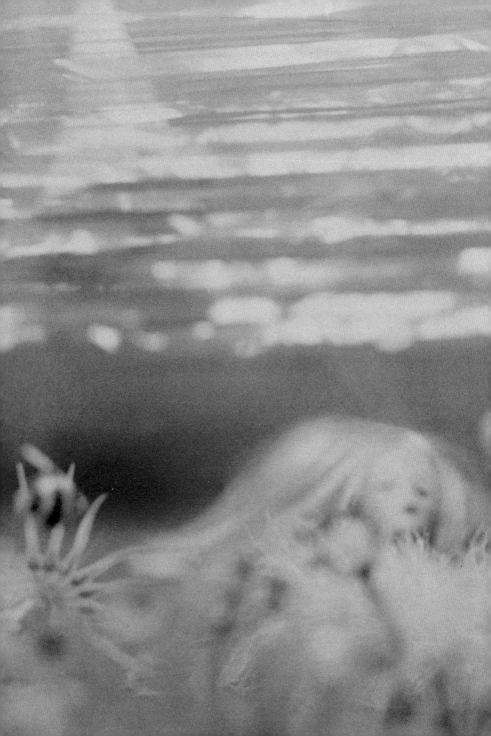

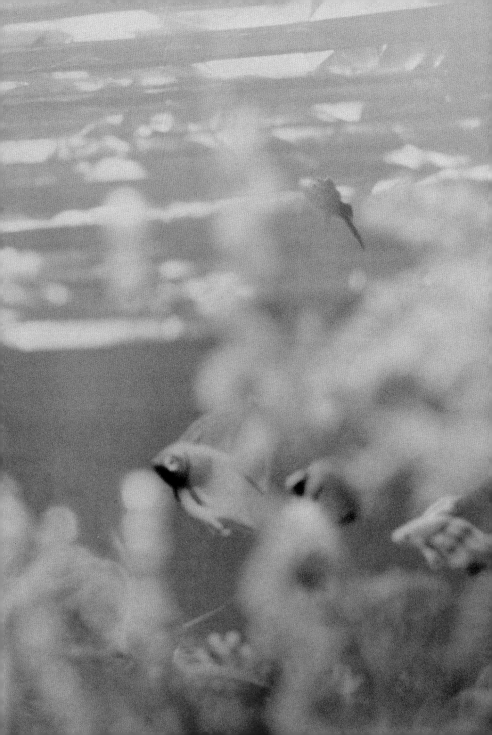

Juliette, 1983

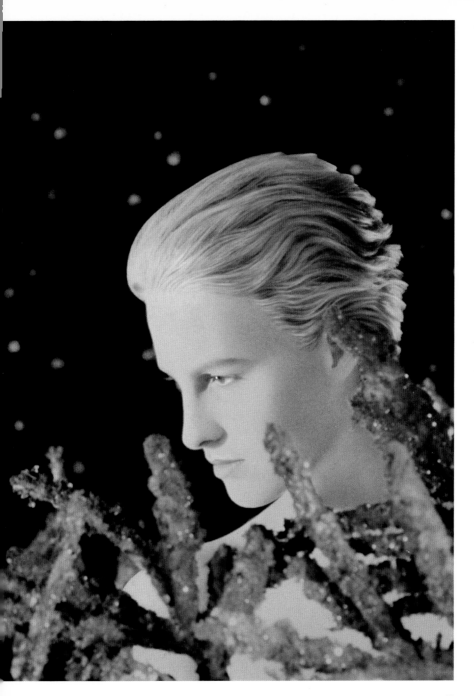

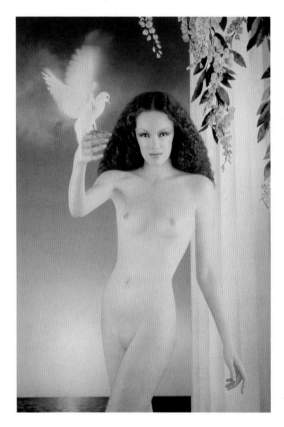

Allyson et la colombe, Allyson, 1981

Lunettes noires, Ed Fry et Marcie Hunt, 1980

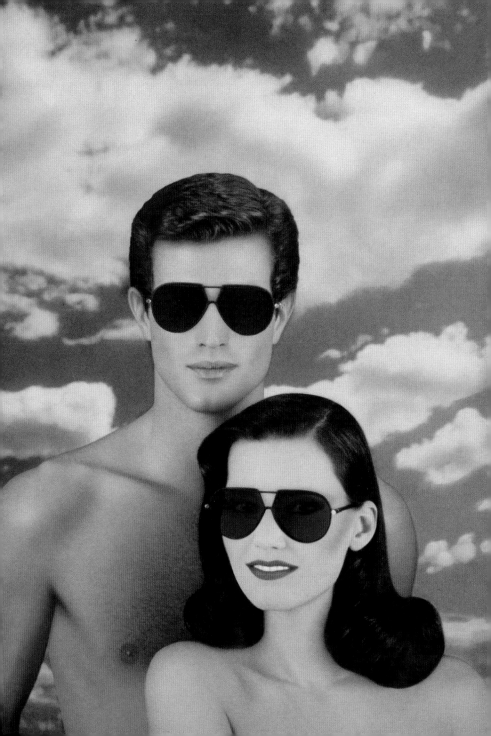

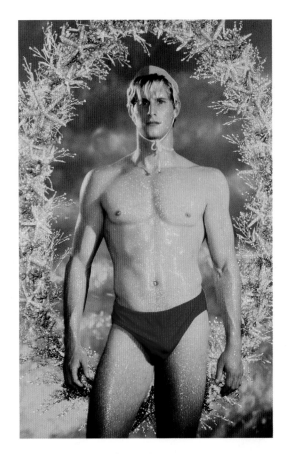

Life saver, Shane, 1995

Les deux poupées, 1985

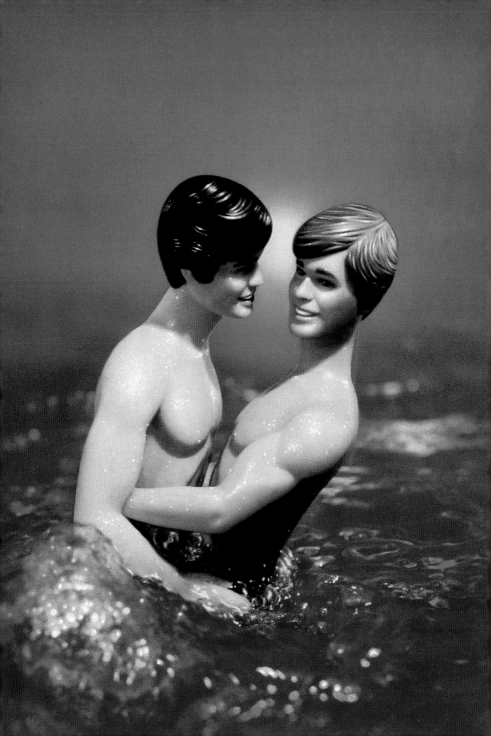

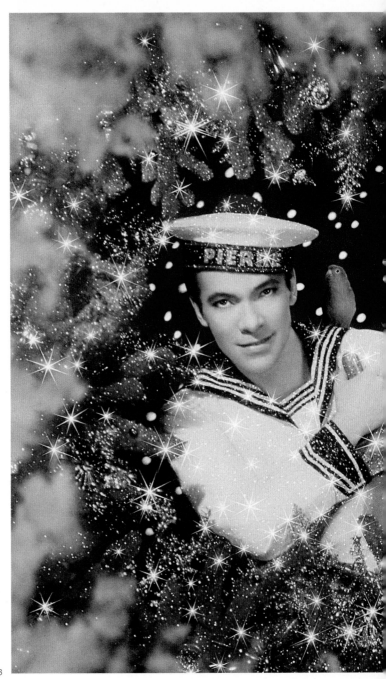

Les deux marins,
Pierre et Gilles, 1993

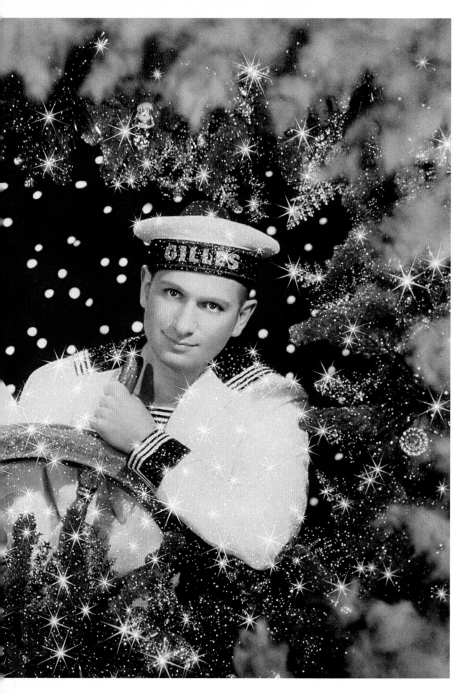

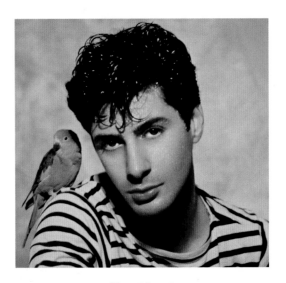

Étienne Daho, 1983

Following pages: **Darling Harbor,** Lance, Richard, Patrick, Victor, Andrew,
Jason, Peter, Scott, Jason, Lindsay, Daniel, Marc, Mark et Shane, 1995

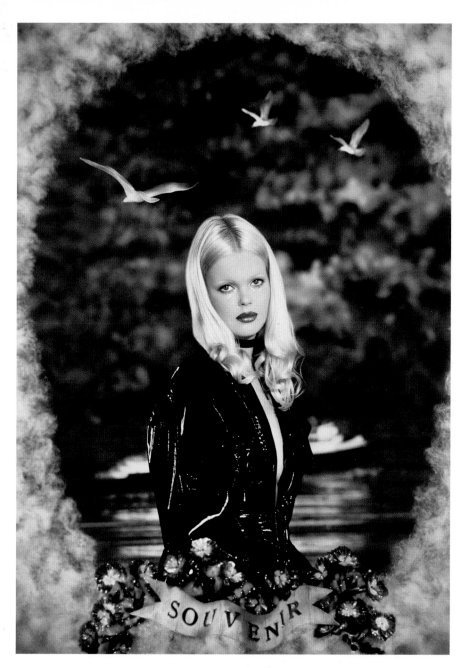

Souvenir, Astrid, 1993

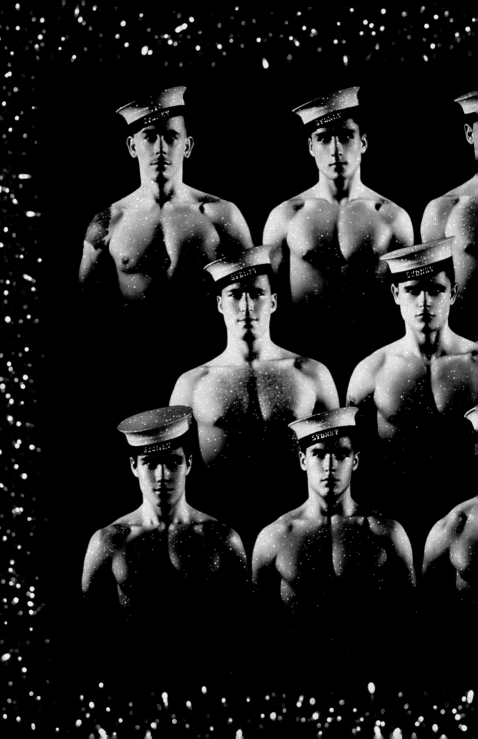

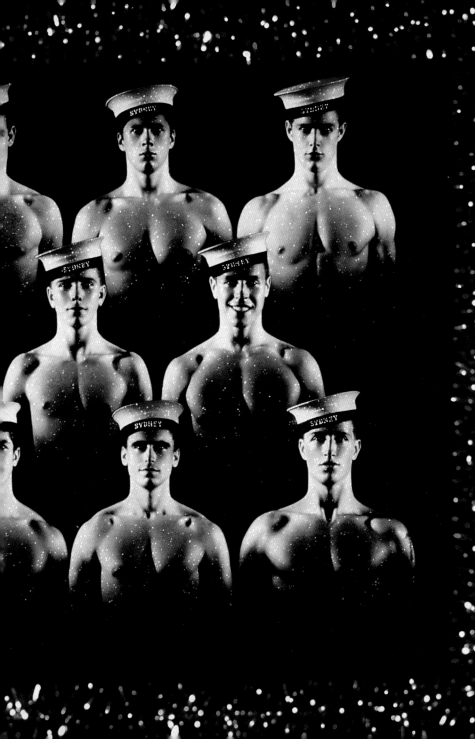

Boys and girls, Enzo, Laurent, Pascale et Sophie, 1994. *Following pages: detail*

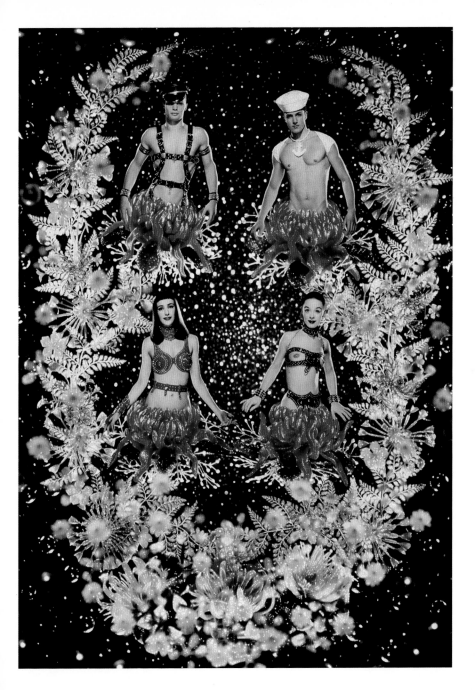

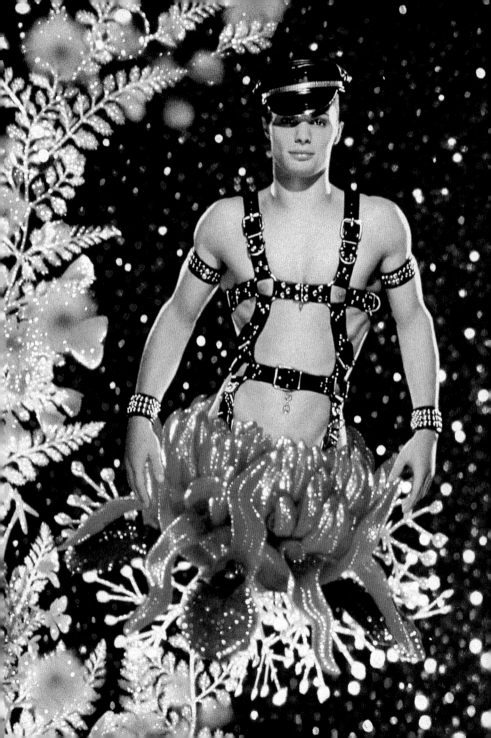

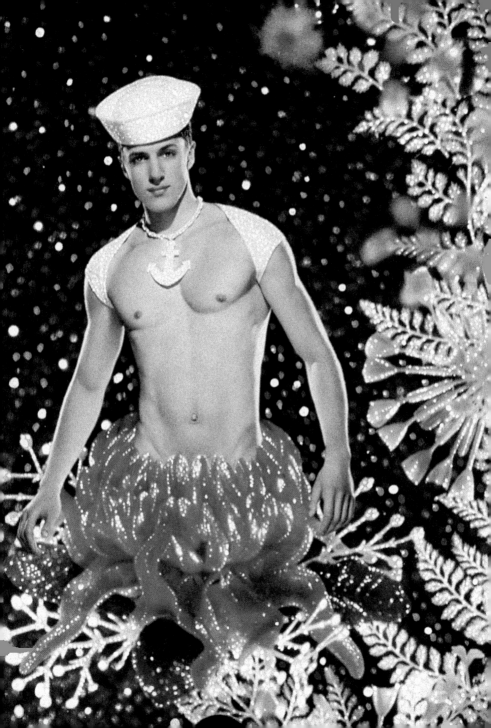

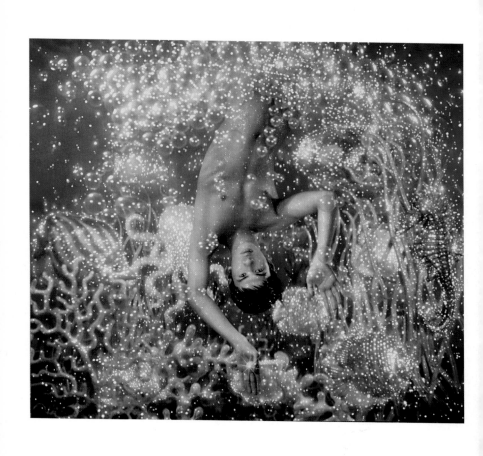

Le pêcheur de perles, Tomah, 1992

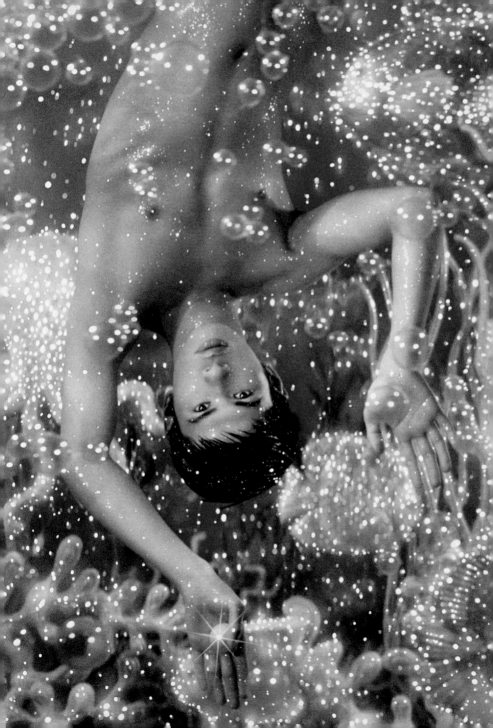

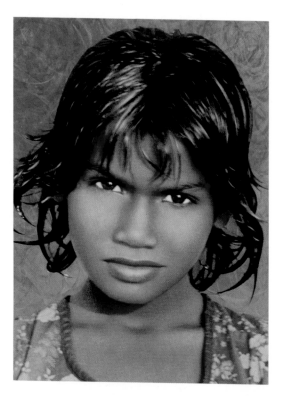

Les enfants des voyages, Maldives, 1982

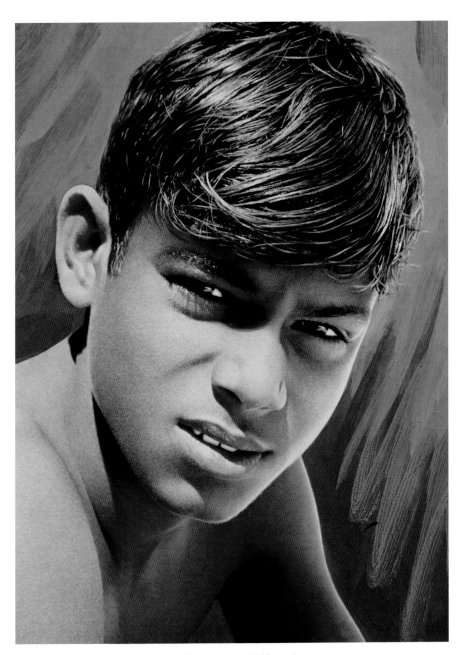

Les enfants des voyages, Maldives, 1982

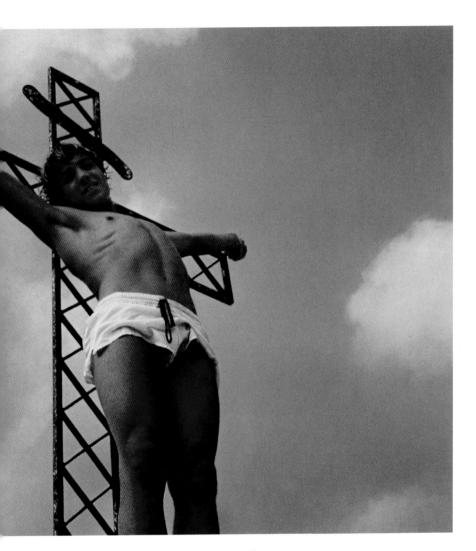

Ragazzo, 1983

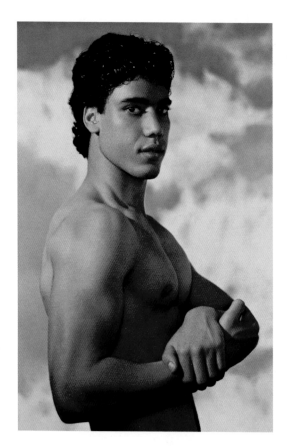

Bouabdallah, 1987

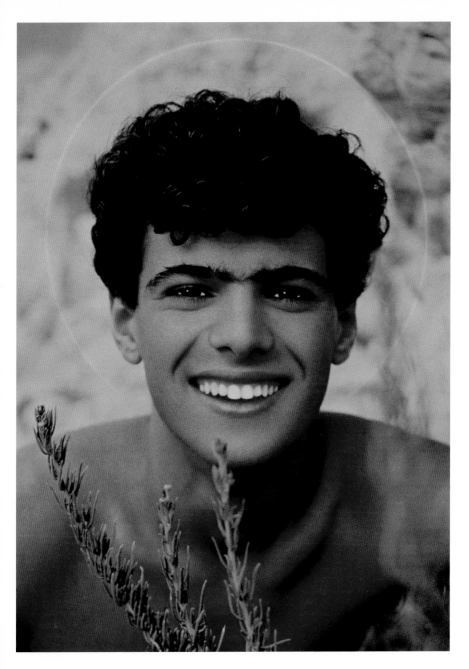

Pietro, 1983

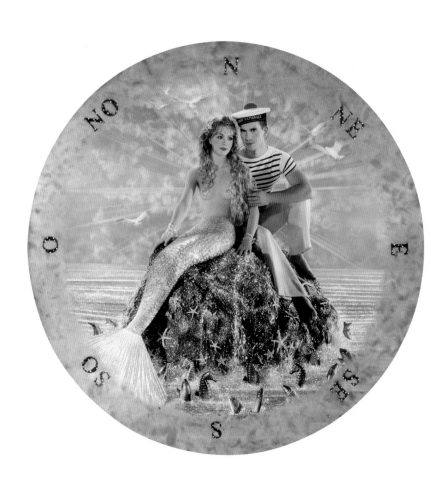

La sirène et le marin, Stéphanie et Didier, 1997

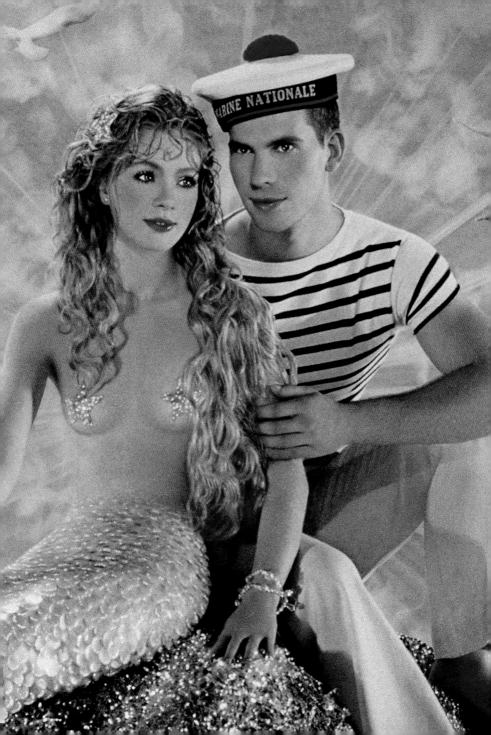

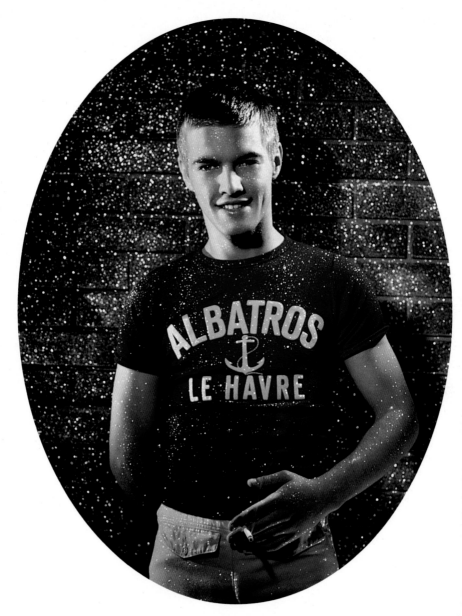

Jolis voyous, Tony, 1995

Le capitaine et son petit mousse, Harry Lunn et Tony, 1995

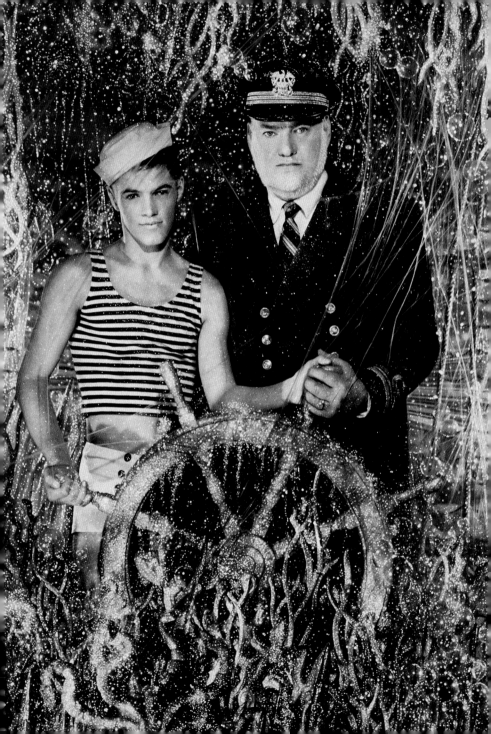

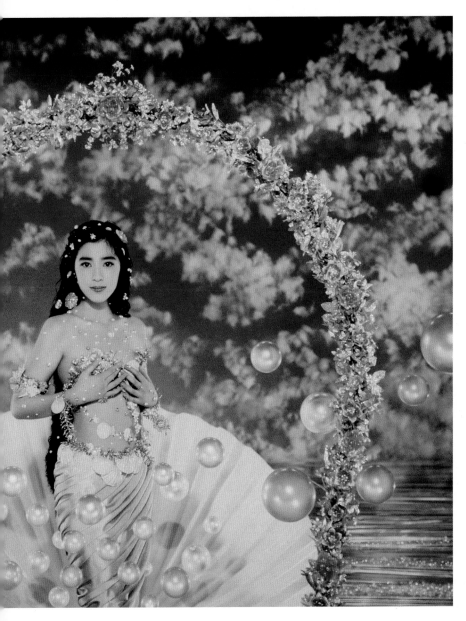

Asian Vénus, Momoko Kikuchi, 1991

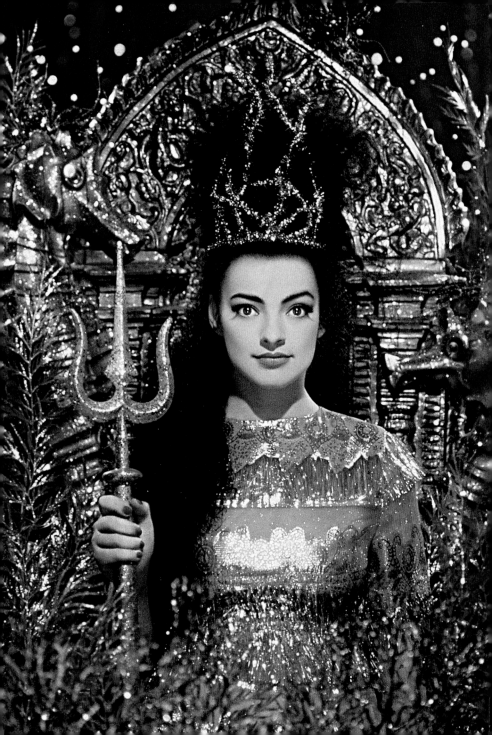

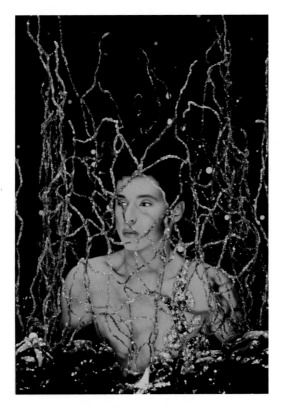

David dans les coraux, David Rocheline, 1984

Amphytrite, Nina Hagen, 1989

Neptune, Karim, 1986

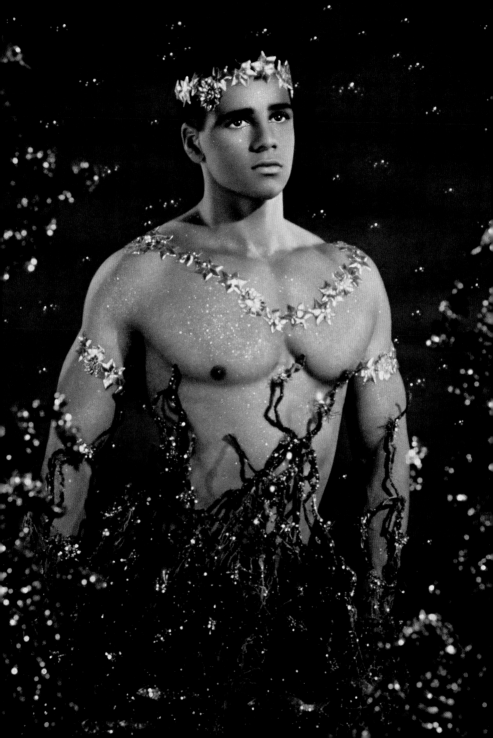

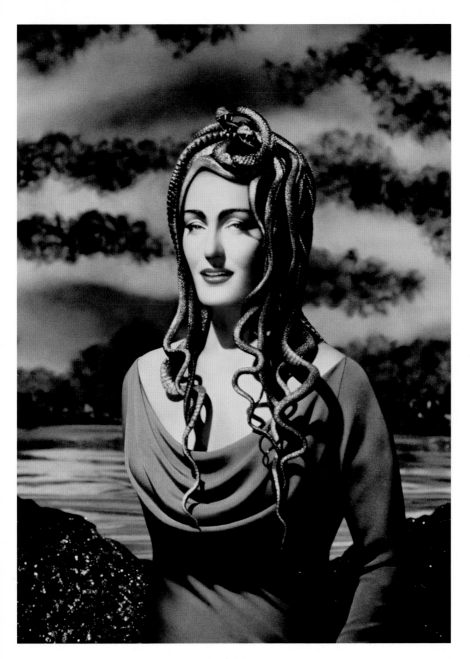

Méduse, Zuleika, 1990

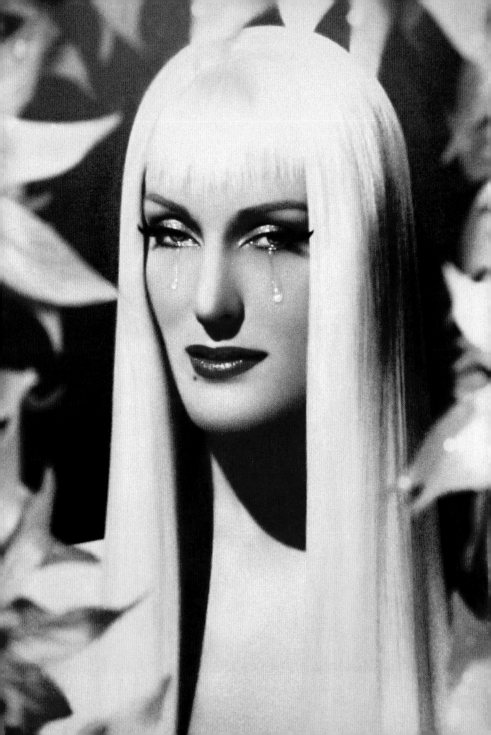

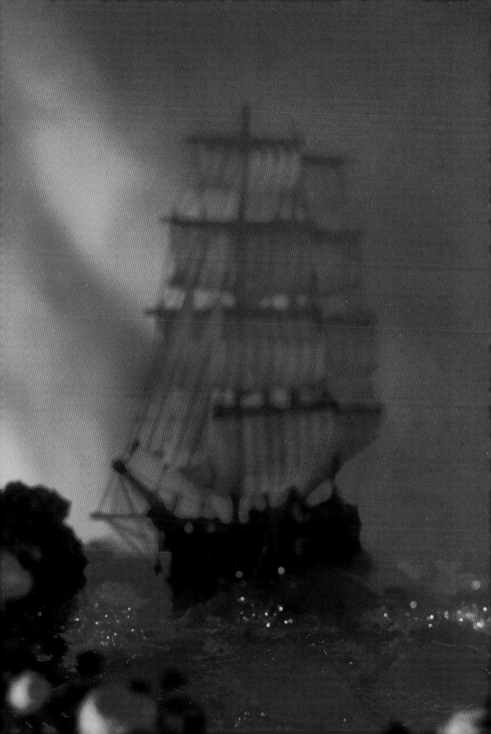

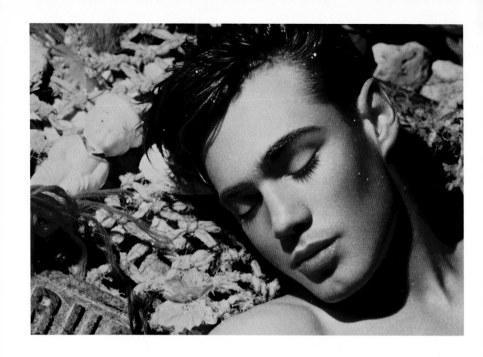

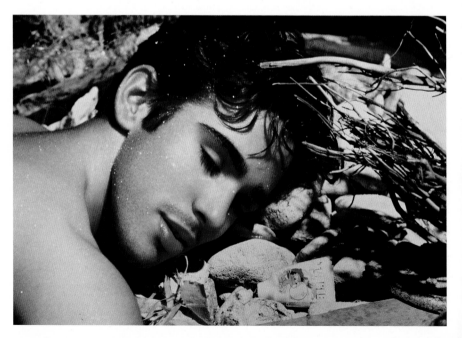

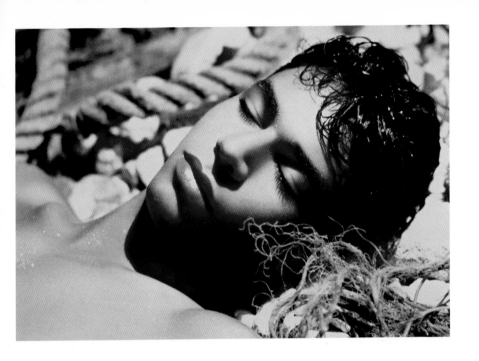

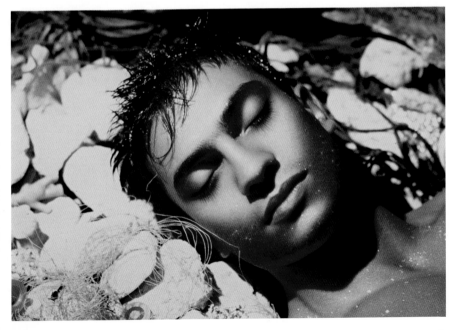

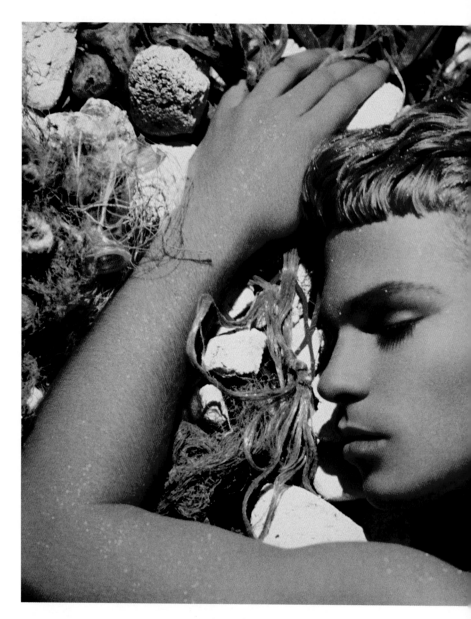

Naufragés, Olivier, 1986

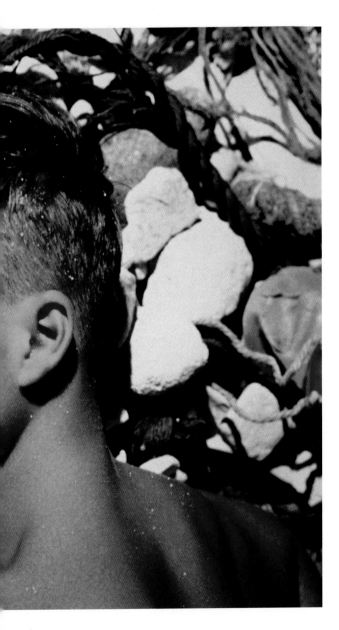

Following pages:

Naufragés, Éric, 1986.

Emmanuel, 1986.

Fabrice, 1986. Stacey, 1985.

Jiro, 1996.

Le martyre de Saint Sébastien,
Jiro, 1996.

Sur le rivage du rêve,
Jiro, 1996.

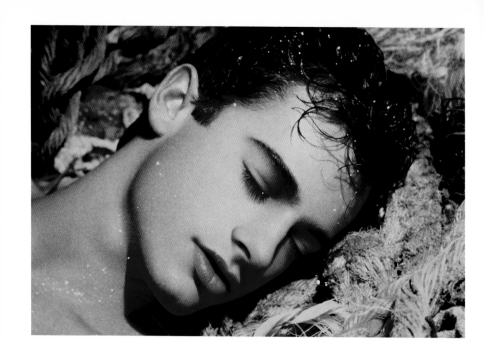

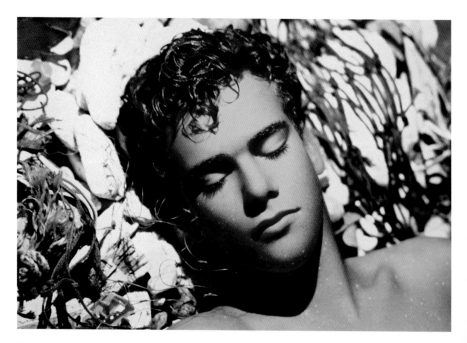

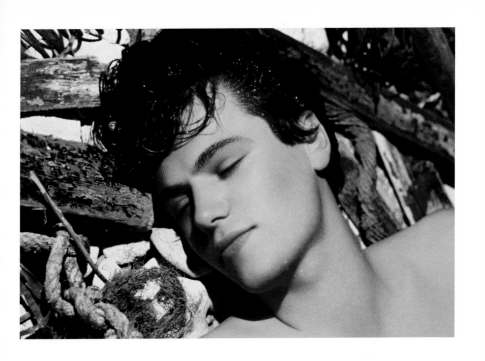

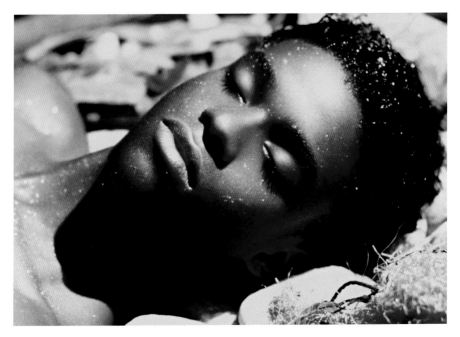

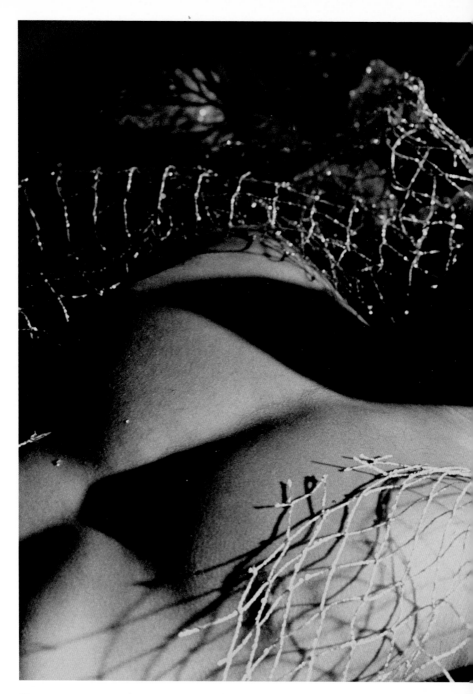

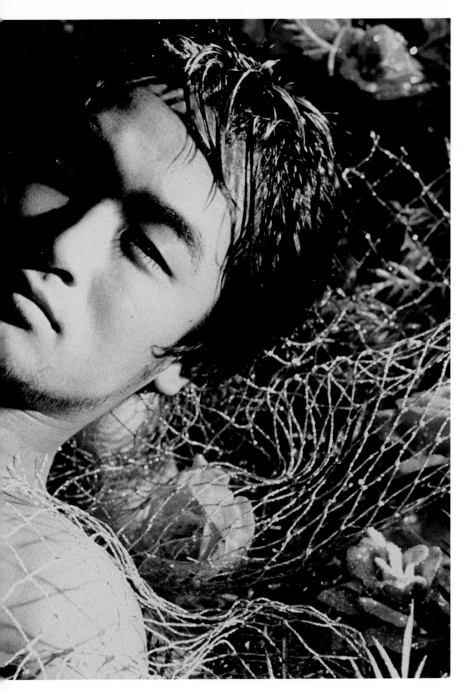

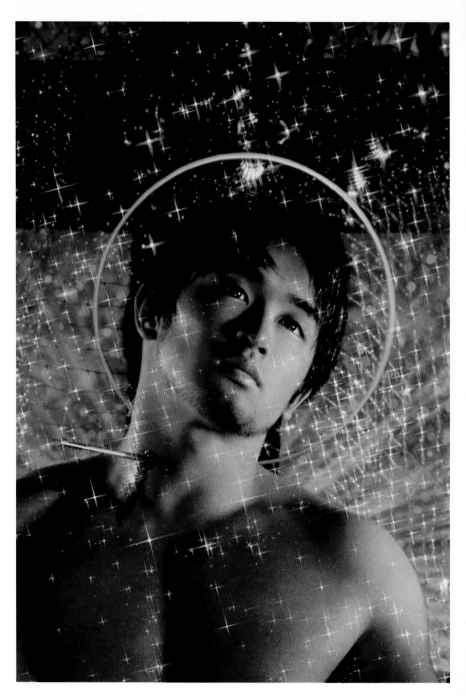

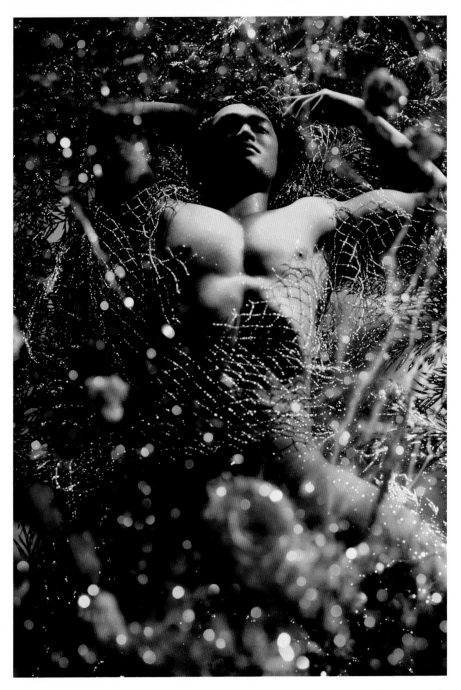

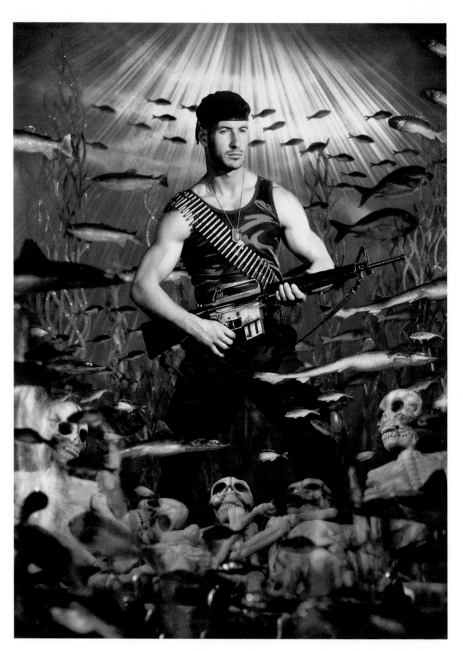

Les fonds marins, Mark Anthony, 1997

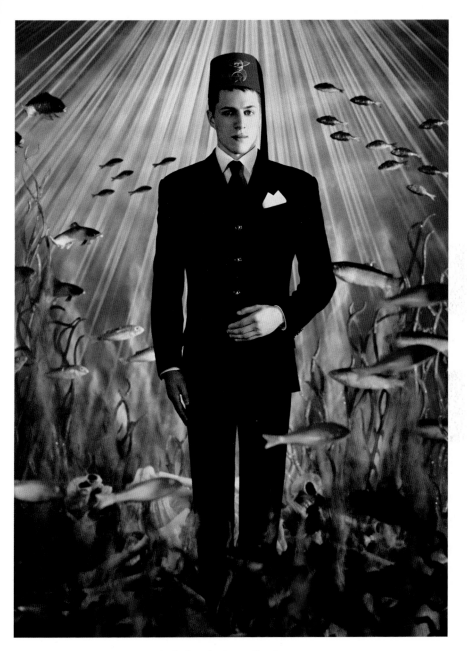

Les fonds marins, Laurent Chemda, 1997

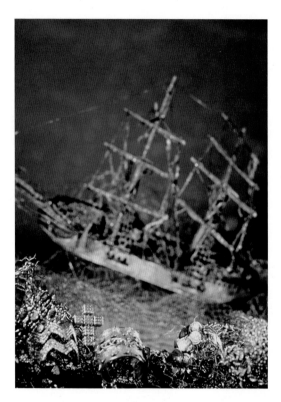

Le galion, 1985

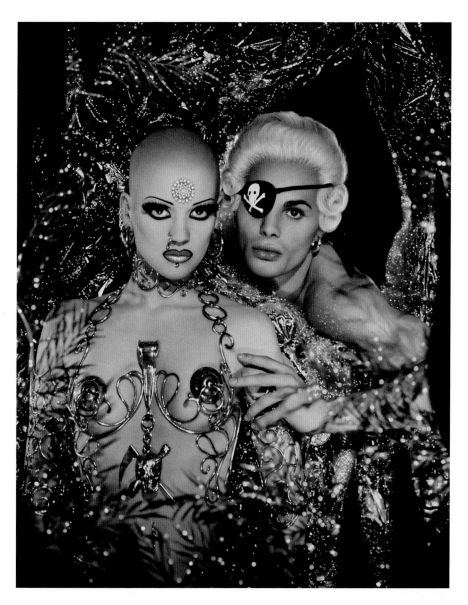

La fiancée du pirate, Polly et Enzo, 1995

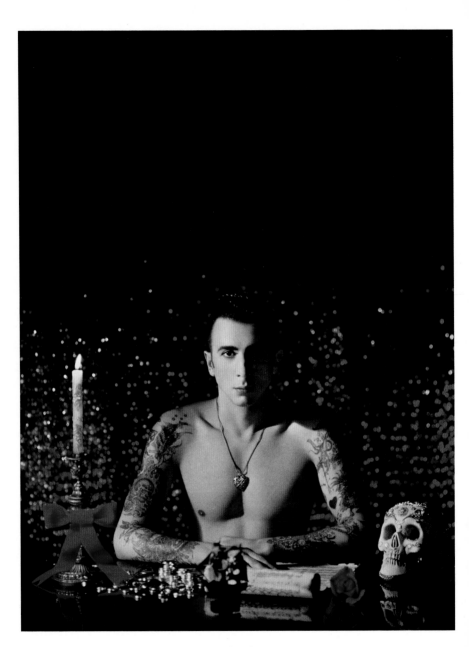

Marc Almond, 1992

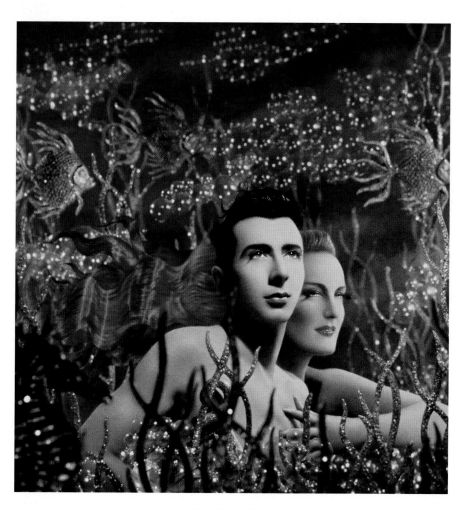

Orphée, Marc Almond et Zuleika, 1990

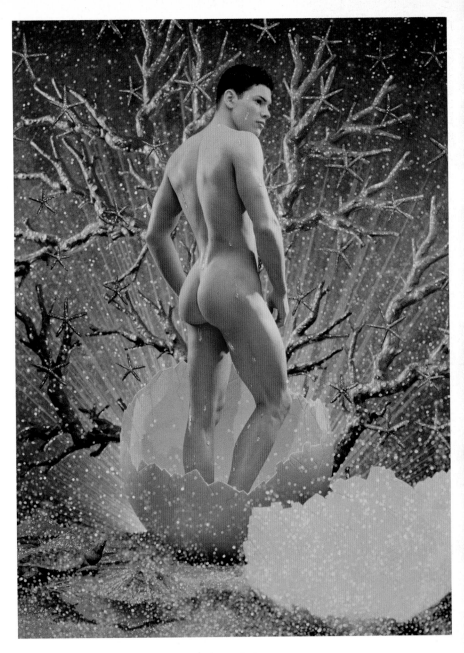

Renaissance, Paul, 1999

Le ciel, les étoiles et la mer, Will, 1998

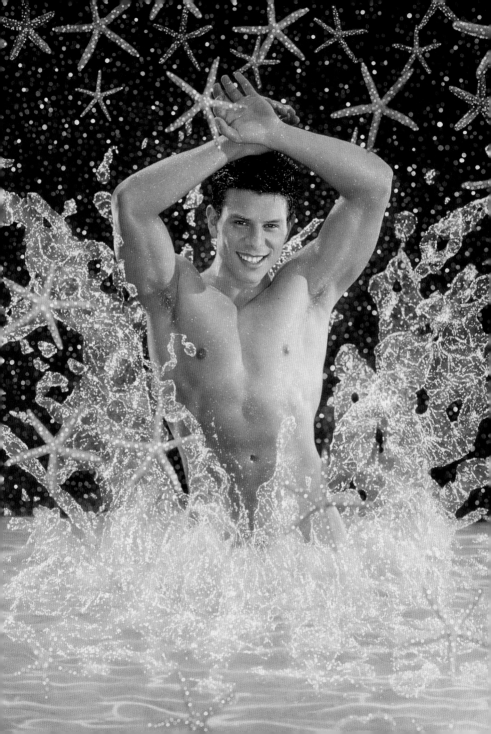

Vénus marine, Laetitia Casta, 2000

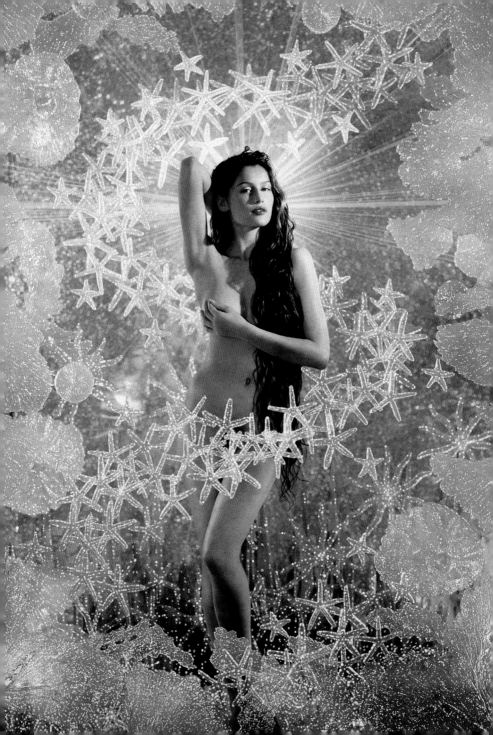

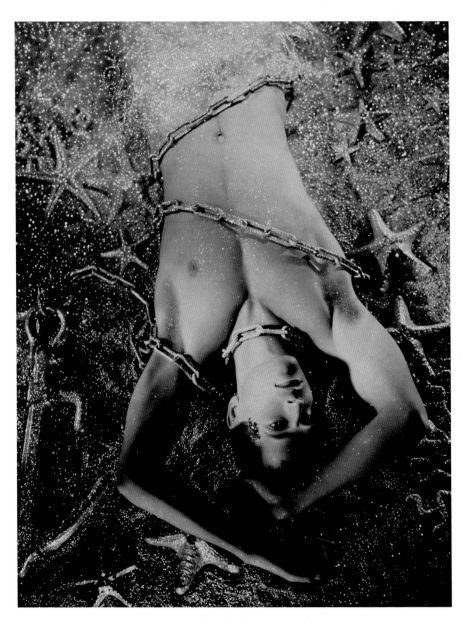

Sur la plage abandonné, Rupert Everett, 1994

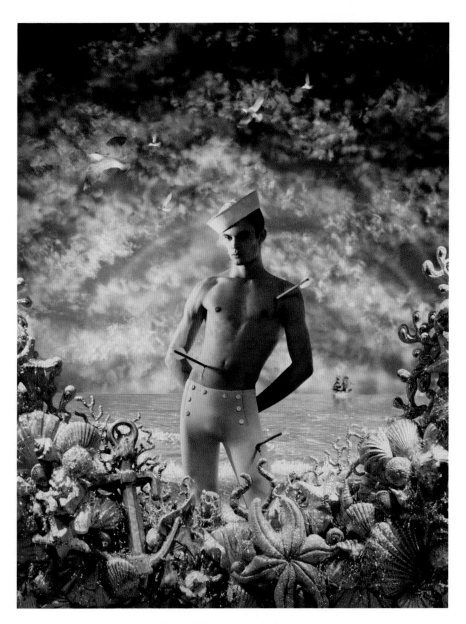

Sébastien de la mer, Laurent Combes, 1994

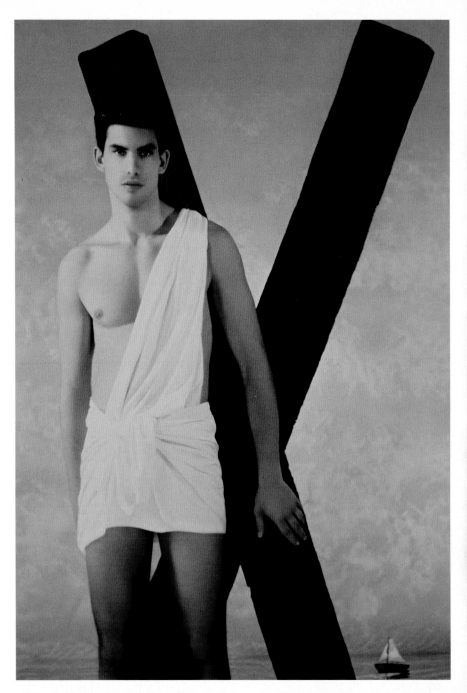

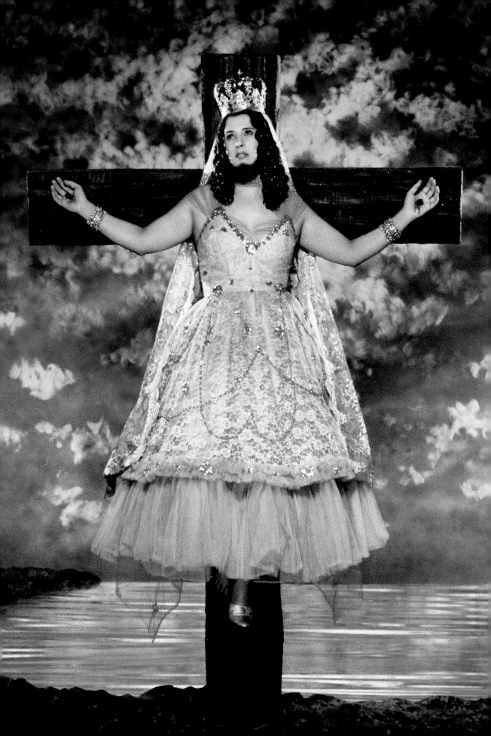

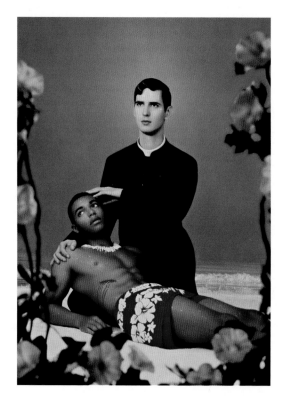

Saint Pierre Marie Chanel, Pascal et Christian, 1990

Previous pages: **Saint André,** Jean Paul, 1988. **Sainte Affligée,** Pascal Borel, 1983

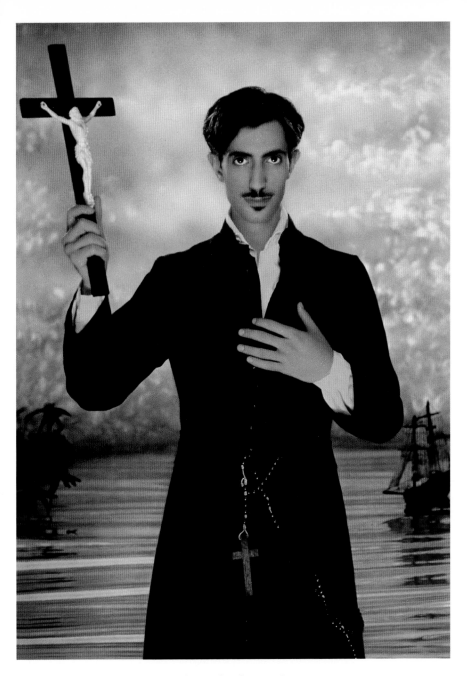

Saint François Xavier, Jerry, 1989

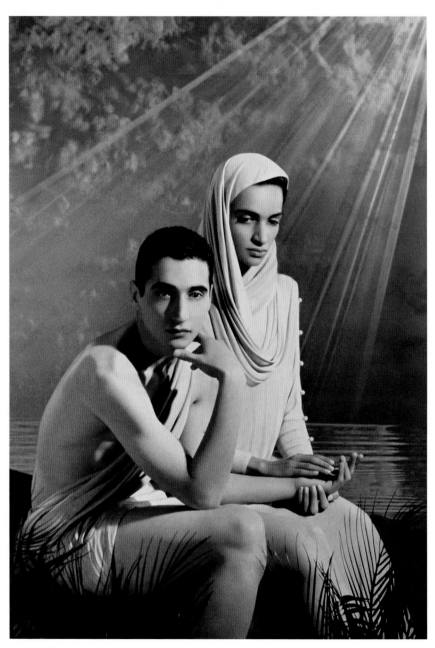

Sainte Monique et Saint Augustin, Farida et Salvatore, 1991

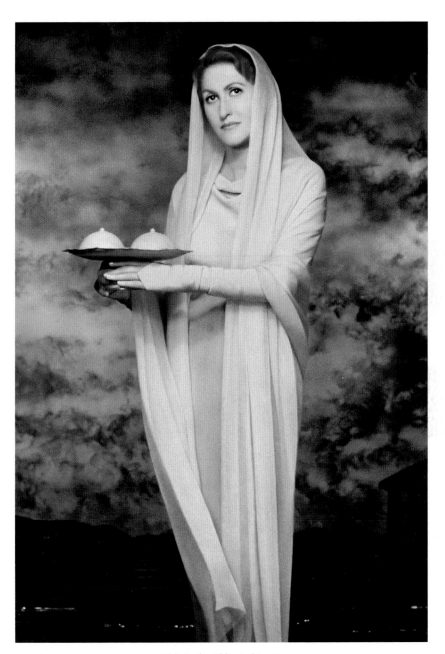

Sainte Agathe, Adeline André, 1989

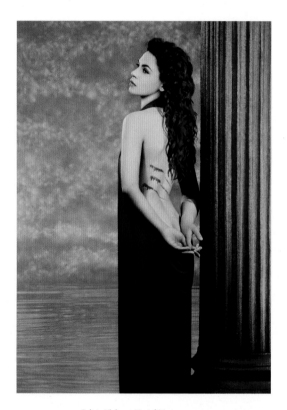

Sainte Viviane, Muriel Moreno, 1990

Saint Jean et Saint Jacques, Charly et Ludovic, 1989

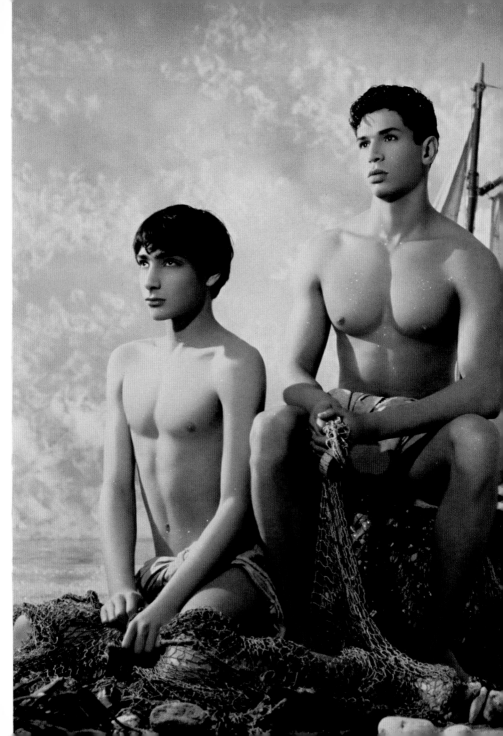

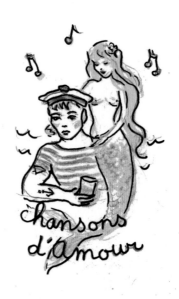

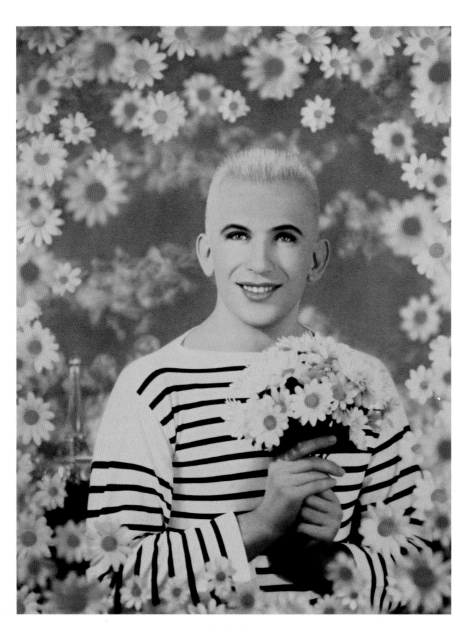

Jean-Paul Gaultier, 1990

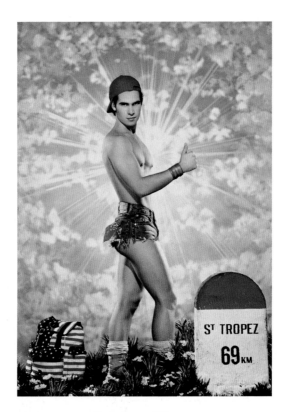

L'auto-stoppeur, Didier, 1994

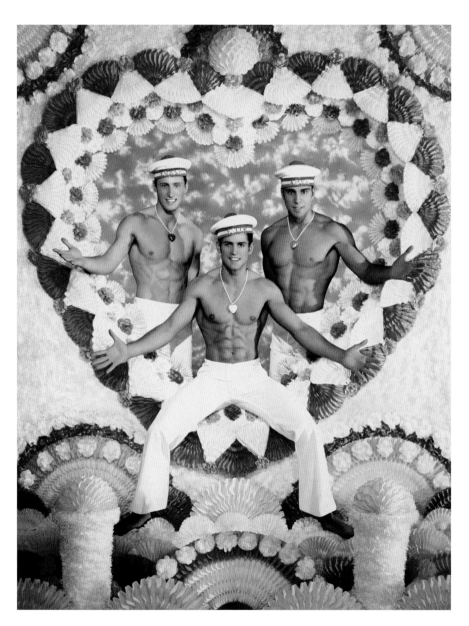

Vive la marine, 2be3, 1999

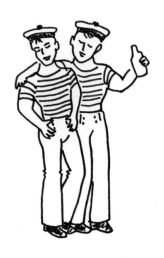

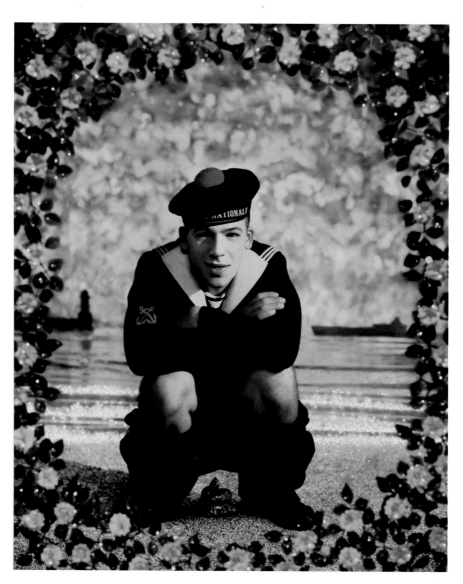

Le petit matelot, Wilfried, 1997

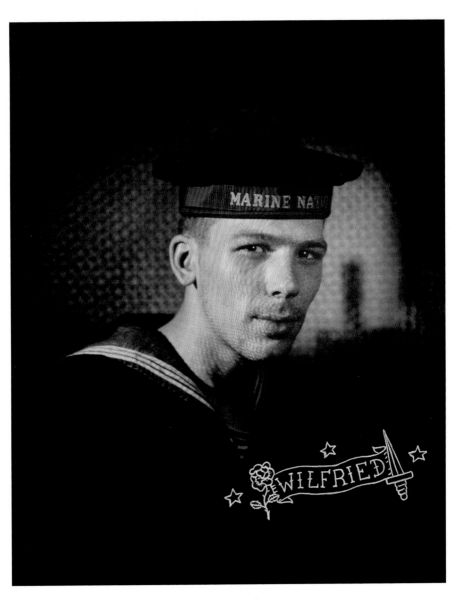

La rose et le couteau, Wilfried, 1998

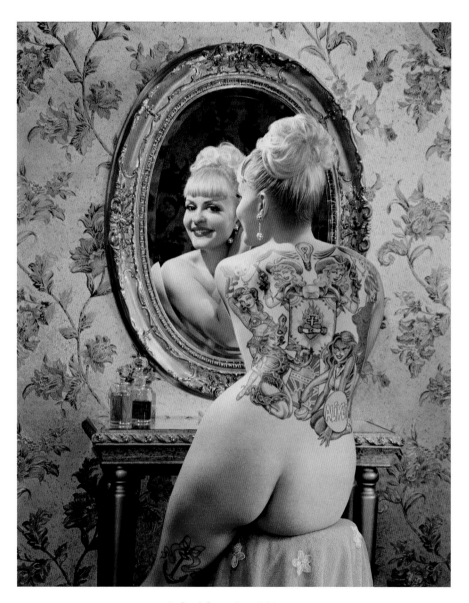

Parfum de femme, Sunny Buick, 2002

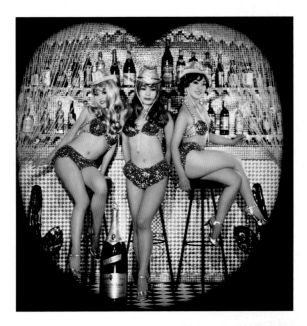

Viva Las Vegas, Las Vegas pink ladies, 1994

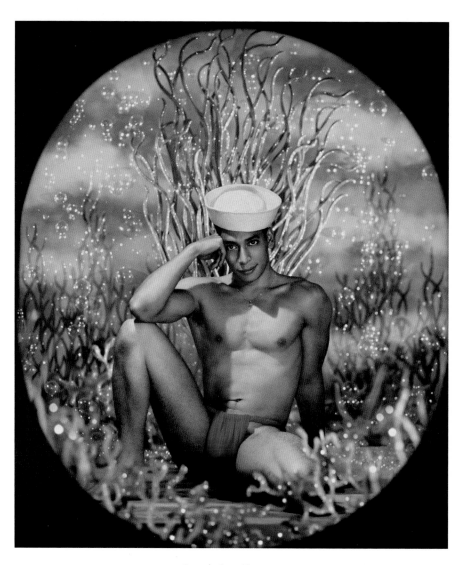

Le marin rêveur, Ken, 1994

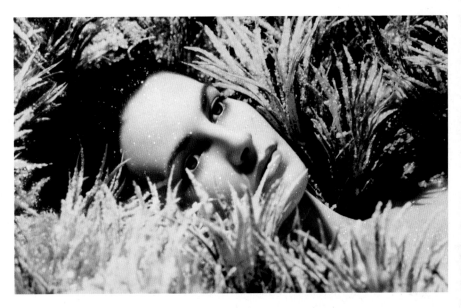

Lio dans les herbes, Lio, 1983

Watercolour, Timo, 1998

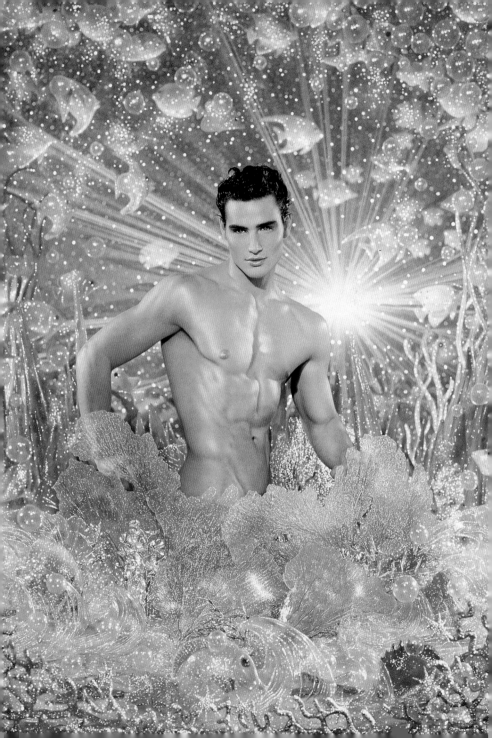

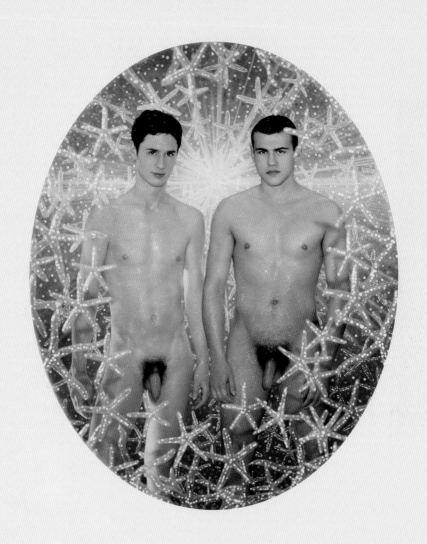

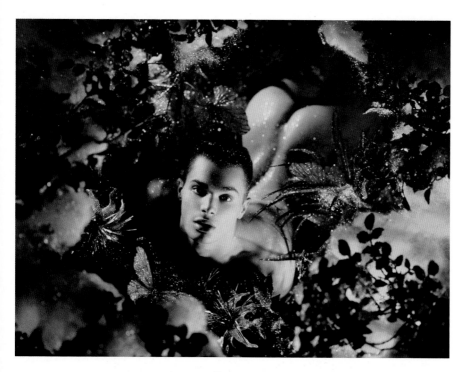

Enzo, 1992

Presque rien, Jérémie Elkaïm et Stéphane Rideau, 2000

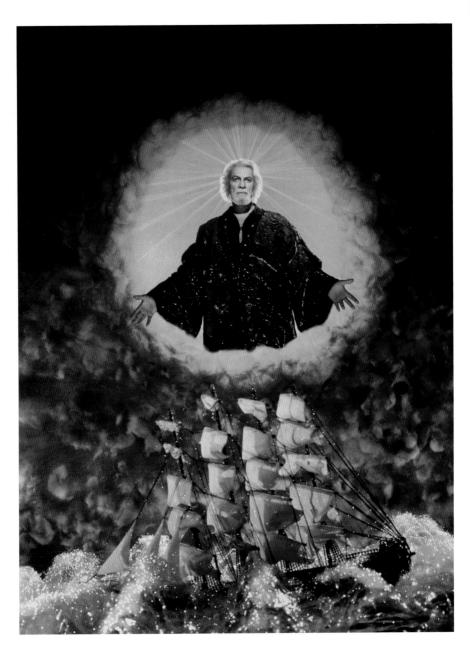

La tempête, Jean Marais, 1997

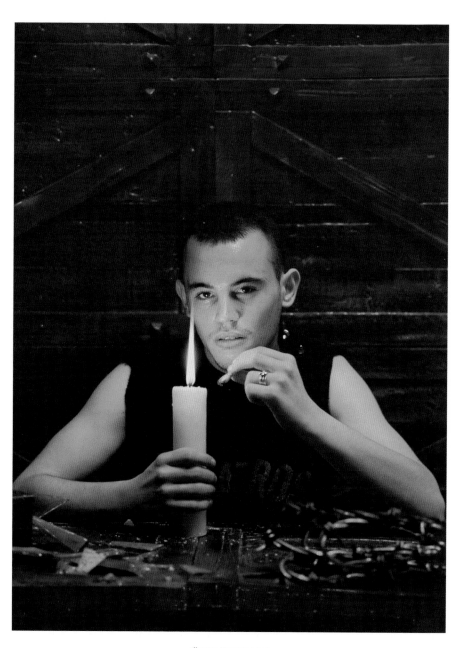

Albatros, Vincent, 1999

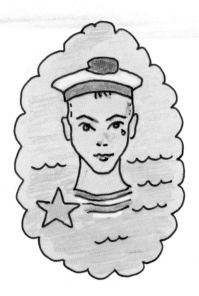

Frog, Jean-Marie, 1999

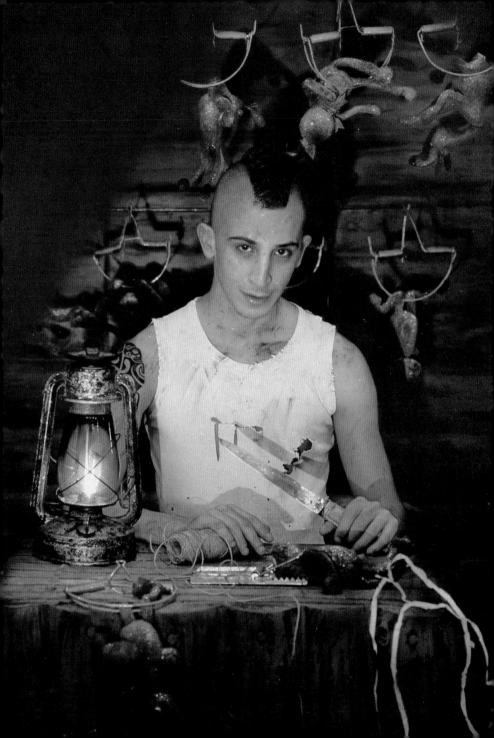

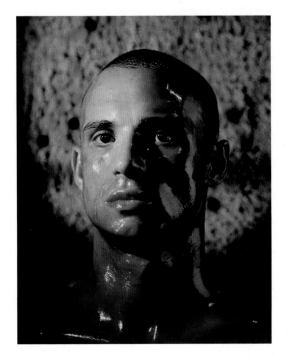

L'aveu, Axel, 2003

Following pages: **Exil intérieur, Mermaid song,** autoportrait, 2002

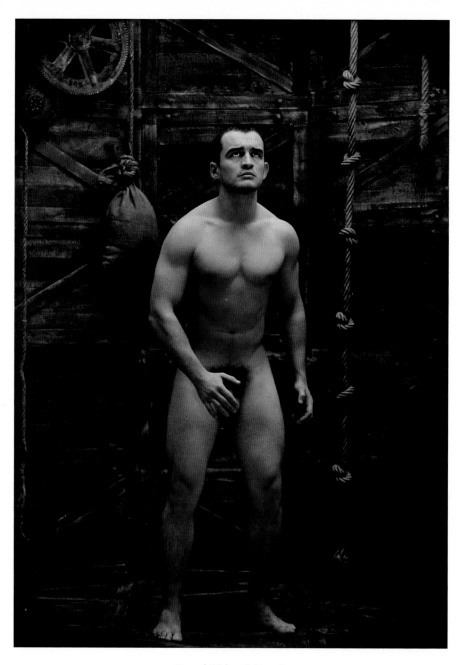

Gaspard, Stéphane Butet, 1998

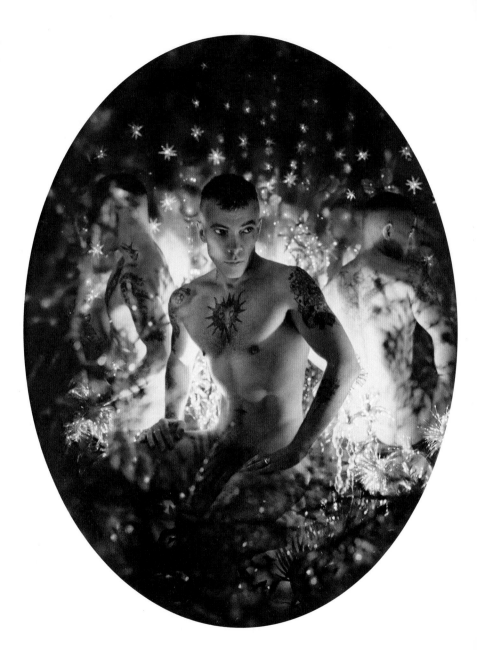

Les portes du rêve, Pierre, 1998

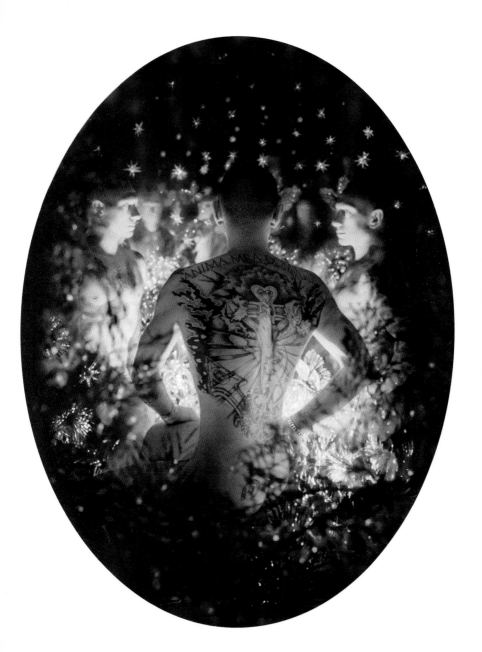

Les portes du rêve, Gilles, 1998

L'escale, l'ange bleu, Sacha, 2003

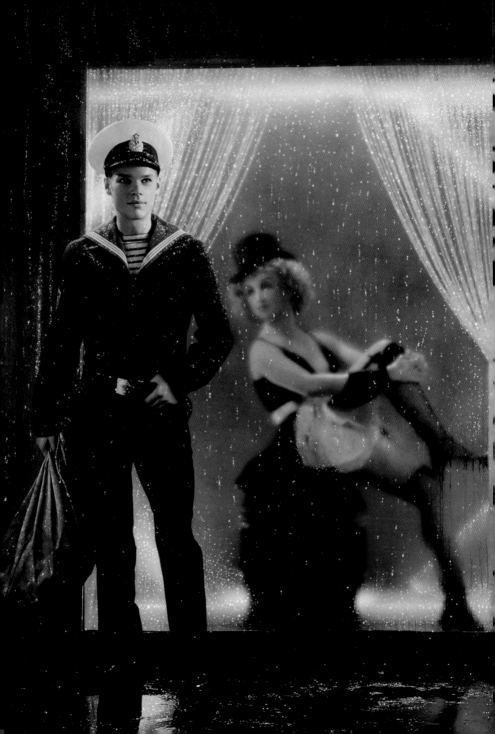

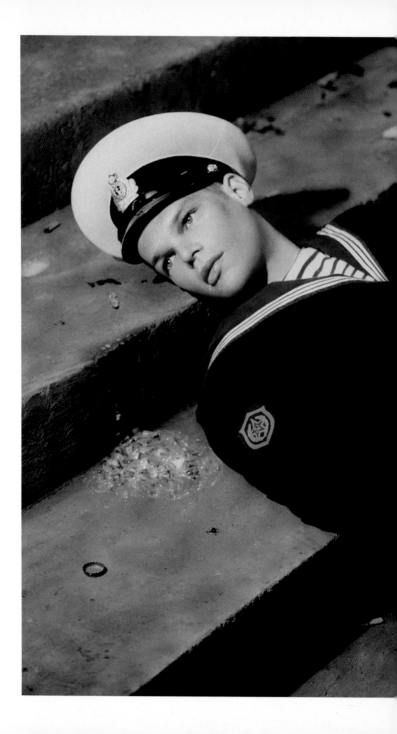

L'escale, petit matin,
Sacha, 2003

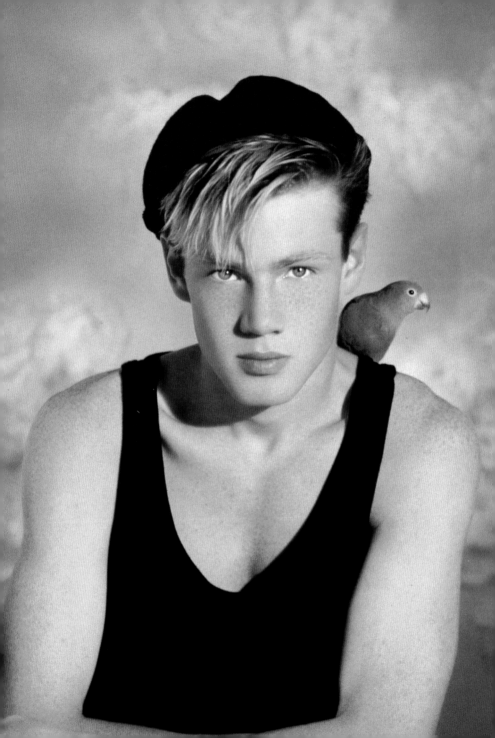

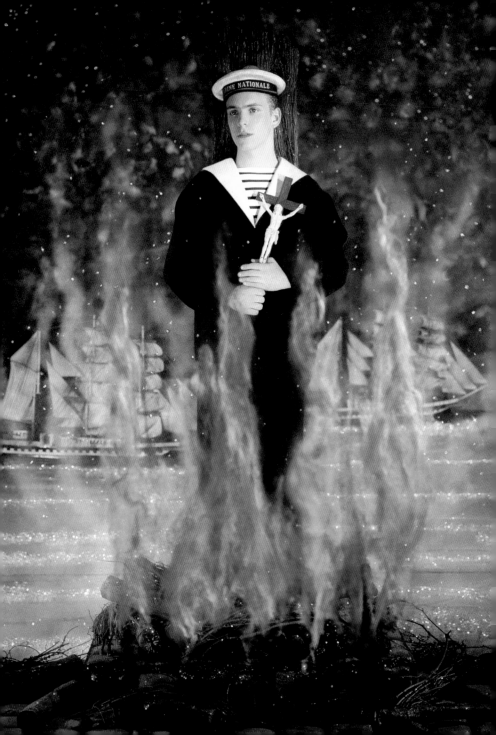

Previous pages: **Le garçon et l'oiseau,** Philippe, 1983. **Le marin au bûcher,** Karl, 1998

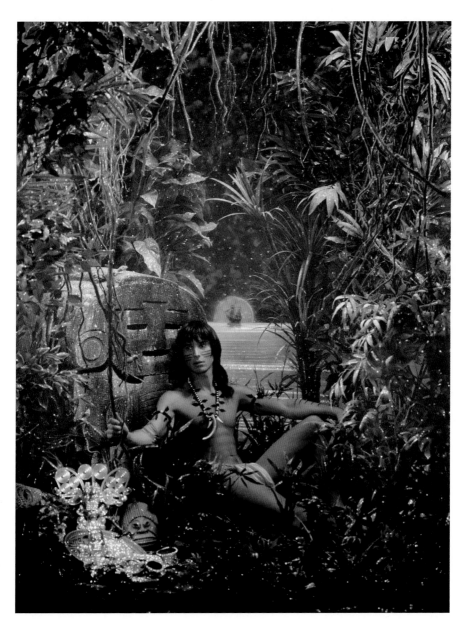

La ciudad perdita, Franky, 2004

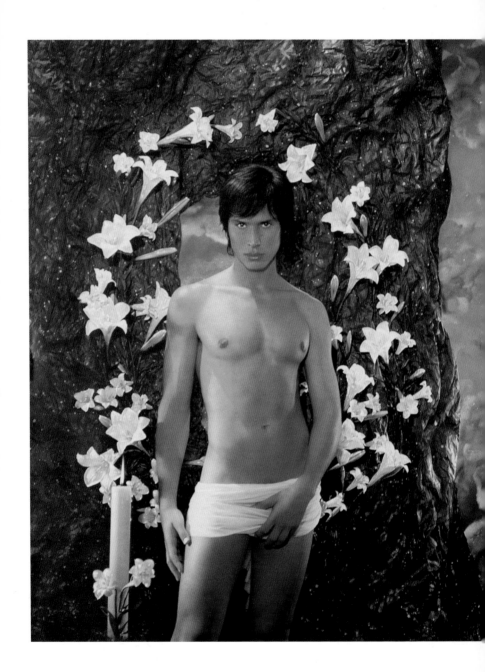

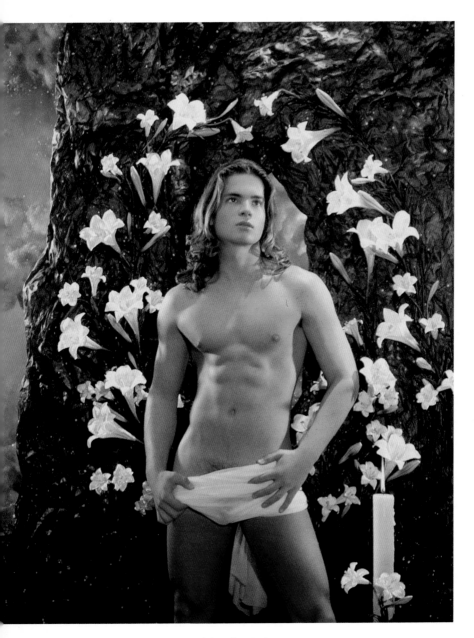

Caïn et Abel, Franky et Esteban, 2001

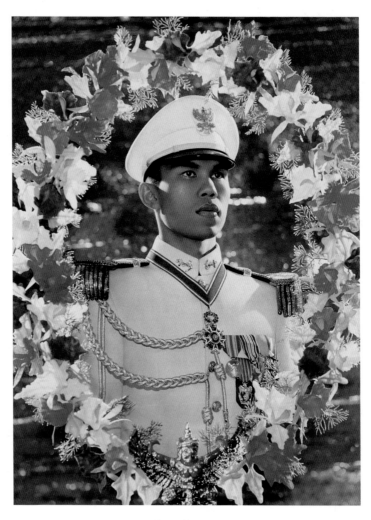

Honor, glory and brave, Pong, 1999

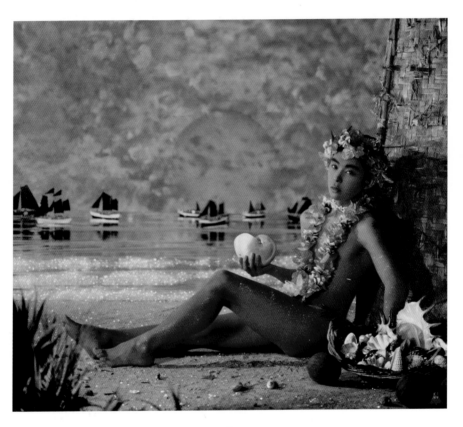

Le ramasseur de coquillages, Koji Kanari, 1992

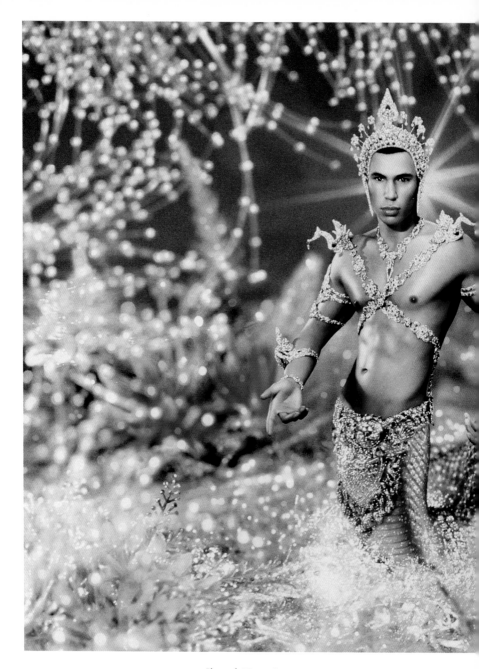

Phayanak, Léo, 1996

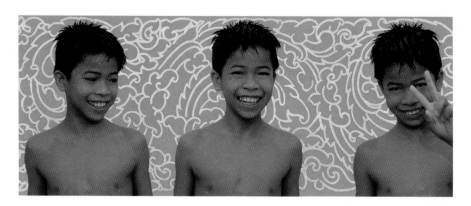

Saibadi, 1994

Les enfants du Laos, 1994

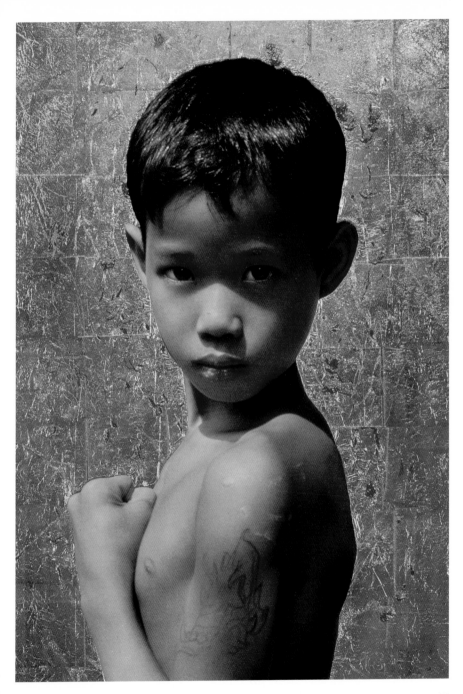

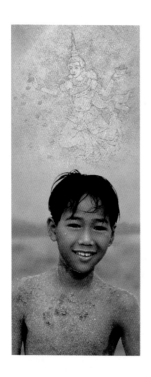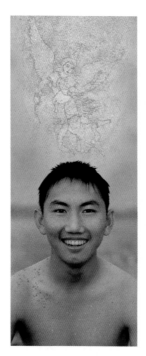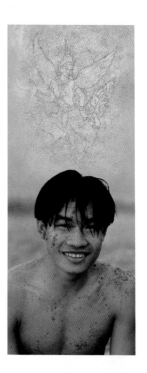

Au bord du Mékong, 1994

Le garçon dans le sable, Vù, 1997

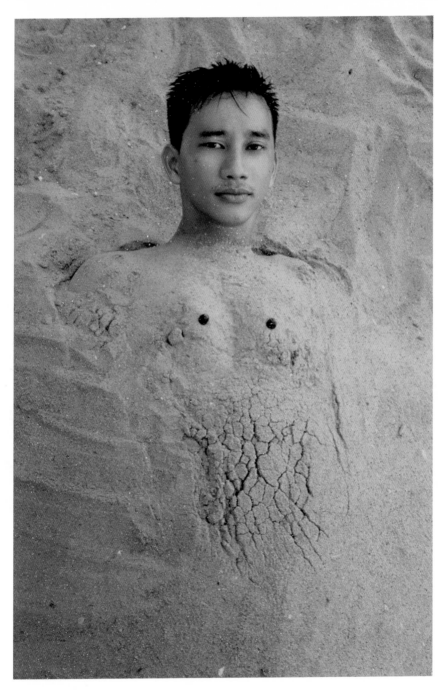

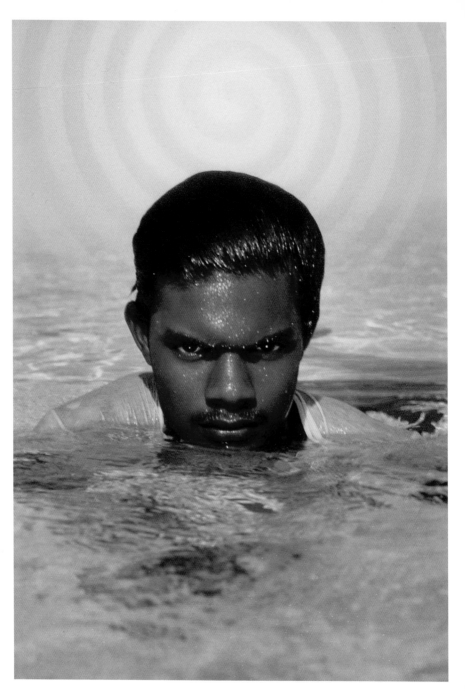

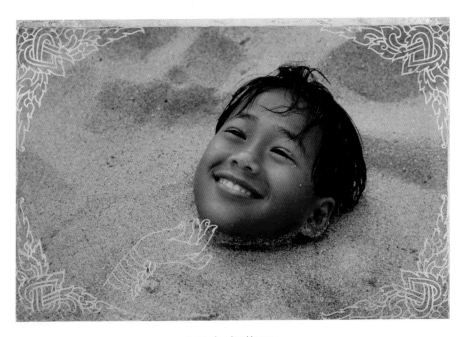

La tête dans le sable, 1994

Le garçon des Maldives, 1982

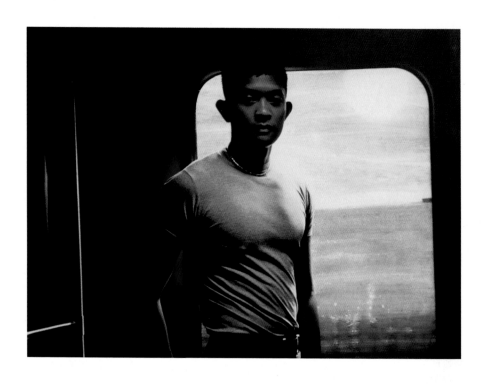

Voiture 17, Prasit, 2000

Toute seule, Ive Björk, 2001

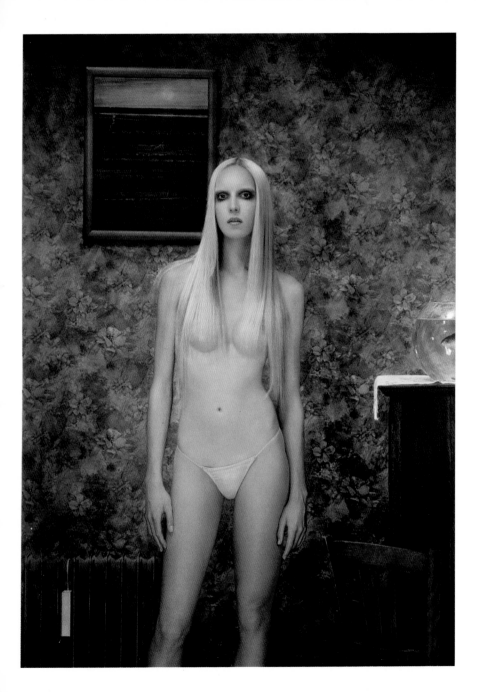

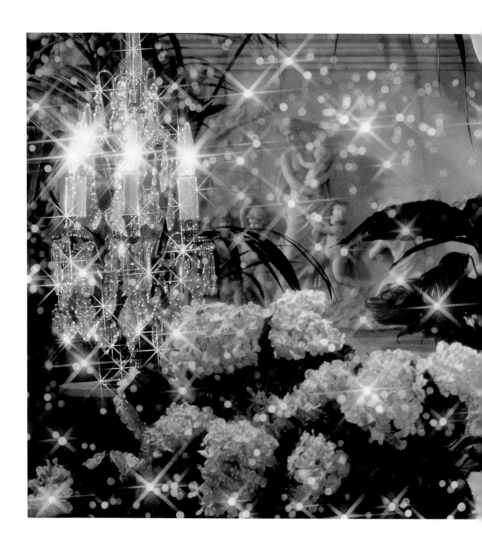

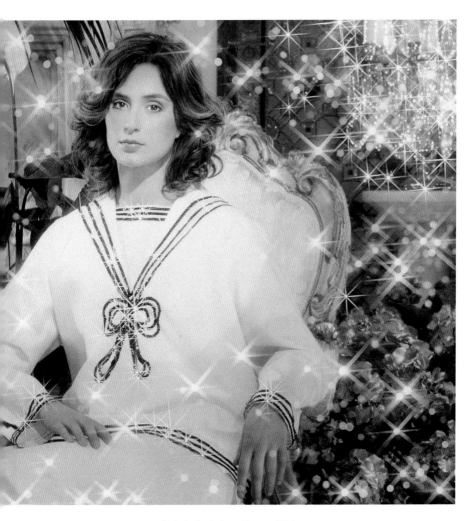

Elizabeth, Elizabeth von Thurn und Taxis, 2004

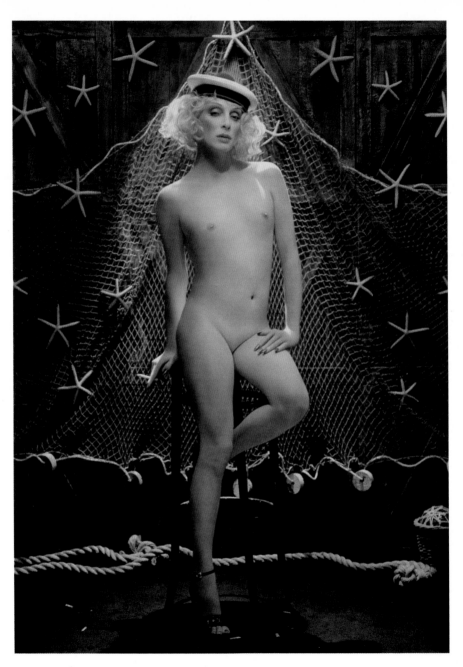

Au bar de la marine, Xitron, 2001

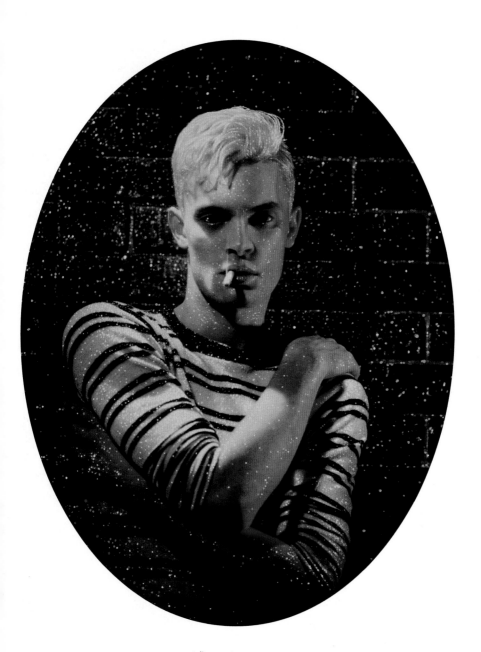

Joli voyou, Laurent, 1994

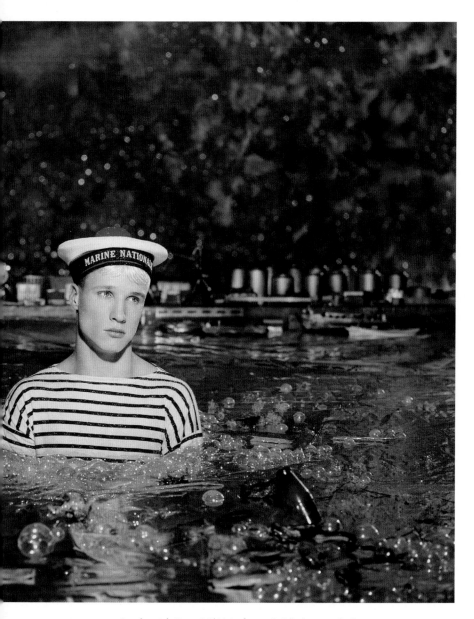

Dans le port du Havre, Frédéric Lenfant, 1998. *Following pages: detail*

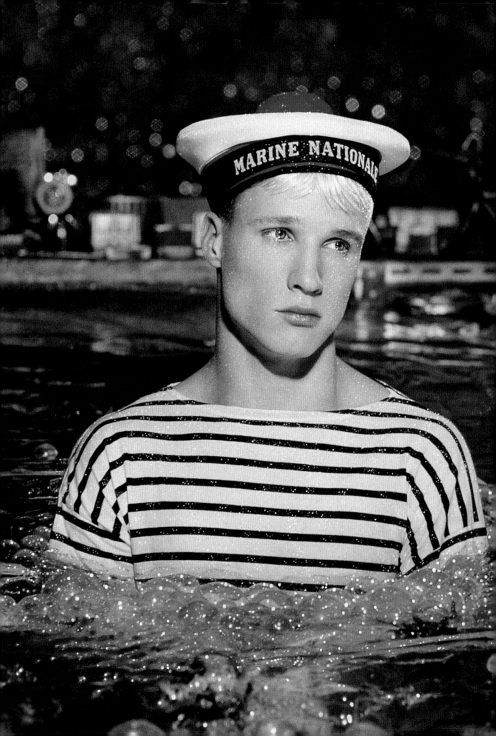

Capitaine Nemo, François Pinault, 2004, *detail*

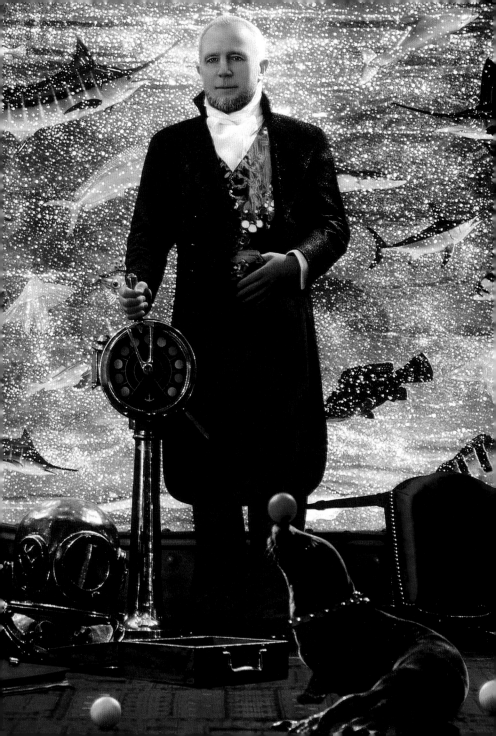

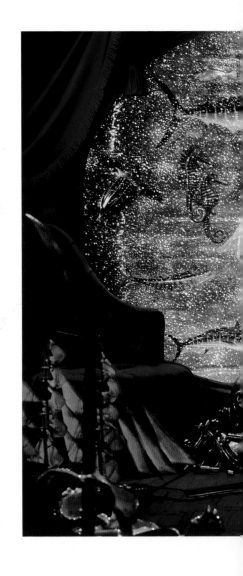

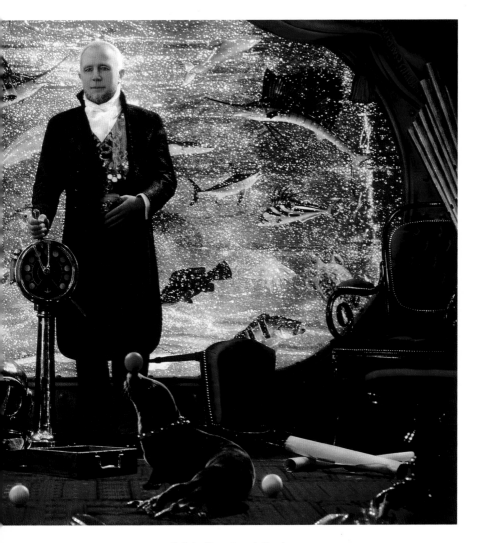

Capitaine Nemo, François Pinault, 2004

PIERRE ET GILLES
Biography

Pierre was born in La Roche-sur-Yon in 1950, Gilles at Le Havre in 1953. In the early seventies, Gilles took a diploma at the École des Beaux-Arts du Havre while Pierre studied photography in Geneva. In 1973, Gilles exchanged letters with Annette Messager over the course of the year. He moved to Paris, where he worked on painting and collage, collected photomatons and made illustrations for magazines and advertisers. Pierre completed his military service in 1973 and began working in Paris as a photographer for the magazines *Rock & Folk*, *Dépêche Mode* and *Interview*.

1976–1981

In the autumn of 1976, Pierre et Gilles met at the opening of the Kenzo boutique in Paris and began to live together in a studio flat on the rue des Blancs-Manteaux in Paris. By 1977, it was obvious to both that they should also work together. Pierre would take photos, Gilles would paint: each contributing to the work of the other.

The images they created for the journal *Façade* established their reputation. They photographed Andy Warhol, Salvador Dalí, Mick Jagger, Yves Saint Laurent and Iggy Pop. They made their first series, *Grimaces*, with their friends as models. 1978 marked the debut of the famous disco-café-theatre Le Palace, for which they made posters and invitations. In 1979, they moved to the Bastille area. They made their first trip to India, worked for Thierry Mugler and designed album covers.

1982–1985

The creation of *Adam et Ève* (Adam and Eve, 1982) marked a turning point in their work. They made their first series in the Maldives and the series *Les enfants des voyages* (Children on the Journey) in Sri Lanka. In 1983, they had their first solo exhibition, at the Galerie Texbraun in Paris with *Les paradis* (Paradises) and *Les garçons de Paris* (Paris Boys).

In 1984, they exhibited at 'Ateliers 84' in the ARC Musée d'Art Moderne de la Ville de Paris. There followed many collaborations with musicians and singers such as Étienne Daho, Lio, Amanda Lear and the Japanese star Sandii.

1985: First pop videos with the group Mikado. Exhibition at the Art Ginza Space in Tokyo.

1986–1996

Exhibition of the *Naufragés* (Shipwrecked) and *Pleureuses* (Weeping Women) series in 1986 at the Galerie Samia Saouma in Paris. First appearance of saints and other religious themes. They began working with Tomah, a young Laotian who worked as their stylist and assistant for the next ten years.

1989 marked the beginning of their friendship with Marc Almond, with whom

they made a video. In 1990, they moved to Pré-Saint-Gervais. Their studio and workshop forms a microcosm of their world, the accumulation of objects having always been one of their sources of inspiration.

They made many trips to Asia. In 1992, they exhibited at the Diaghilev Museum of Modern Art, St Petersburg, and in 1995 in Moscow. In 1993, they were awarded the Grand Prix de Photographie de Paris. In 1994, they made the series *Au bord du Mékong* (On the Banks of Mekong) in Laos and *Boxeurs Thaï* (Thai Boxers) in Bangkok. In 1995, they exhibited at the Roslyn Oxley9 Gallery in Sydney and designed the posters for the Sydney 'Gay & Lesbian Mardi Gras'. They worked on the *Jolis voyous* (Pretty Thugs) and *Les plaisirs de la forêt* (Forest Pleasures) series. In 1996, they had their first retrospective, at the Maison Européenne de la Photographie in Paris, where they created a series of scenographies matching the themes they had chosen; the exhibition was a great success. The catalogue, edited by Bernard Marcadé and Dan Cameron and published by TASCHEN, established itself as a work of international authority.

1997–1999

In 1998, the Museo de Bellas Artes de Valencia held a Pierre et Gilles retrospective. *Douce Violence* (Gentle/Sweet Violence) was the title of their first exhibition at the Galerie Jérôme de Noirmont in Paris, in December; this gallery became their exclusive representative. In 1999, they took part in the exhibition *Rosso Vivo* at the Padiglione d'Arte Moderna in Milan and a retrospective of their works was held at the Turun Taidermuseo in Turku, Finland.

2000

The year 2000 was a very eventful one for Pierre et Gilles. A major exhibition was devoted to them within the *Appearance* exhibition at Bologna. They also took part in the huge *Beauty* exhibition in Avignon, for which they created an installation of their work *Radha et Krishna* (Radha and Krishna).

Then came the ultimate accolade, a retrospective at the New Museum in New York and the Yerba Buena Center for the Arts in San Francisco, which was a sensational success with the American public. They met Kenneth Anger and James Bidgood, with whom they have maintained a close friendship.

2001–2005

Their second solo exhibition at the Galerie Jérôme de Noirmont opened on 9 November 2001: *Arrache mon cœur* (Tear out My Heart). The exhibition went on to the KunstHaus in Vienna in 2002. The *Album Pierre et Gilles*, a volume reproducing some 540 of their works, appeared in late 2002.

In 2004, Pierre et Gilles had their first retrospective in Asia: *Beautiful Dragon* was first exhibited at the Seoul Museum of Art in Korea, then at the Singapore Art Museum. Their third solo exhibition at the Galerie Jérôme de Noirmont, *Le Grand Amour* (Great Love), opened on 24 September 2004.

Pierre wird 1950 in La Roche-sur-Yon geboren, Gilles 1953 in Le Havre. Anfang der siebziger Jahre erhält Gilles sein Diplom an der École des Beaux-Arts in Le Havre, unterdessen studiert Pierre in Genf Fotografie. 1973 korrespondiert Gilles ein Jahr lang mit Annette Messager und lässt sich in Paris nieder. Er malt, macht Collagen, sammelt Photomatons (automatische Fotografiermaschinen, die nach kurzer Zeit fertige Aufnahmen auswerfen) und fertigt Illustrationen für Zeitschriften und für die Werbung an. Nach seinem Militärdienst 1973 arbeitet Pierre in Paris als Fotograf für die Magazine *Rock & Folk, Dépêche Mode* und *Interview*.

1976–1981

Im Herbst 1976 lernen sich Pierre und Gilles bei der Einweihung einer Kenzo-Boutique in Paris kennen und leben von da an miteinander. Ihre Atelierwohnung liegt in der Rue des Blancs-Manteaux in Paris. Seit 1977 arbeiten die beiden ständig zusammen. Pierre macht die fotografischen Aufnahmen, und Gilles übernimmt den malerischen Part, und jeder mischt bei den Aufgaben des anderen mit.

Ihre Bilder für die Zeitschrift *Façade* machen sie bei einem breiten Publikum bekannt. Sie fotografieren Andy Warhol, Salvador Dalí, Mick Jagger, Yves Saint Laurent und Iggy Pop. Außerdem entsteht ihre erste Serie *Grimaces* (Grimassen) mit ihren Freunden als Modellen. Das Jahr 1978 markiert den Beginn der Ära des Clubs *Palace,* für den sie Plakate und Einladungskarten entwerfen ... 1979 ziehen sie in das Bastille-Viertel um. Sie reisen zum ersten Mal nach Indien. Sie arbeiten für Thierry Mugler und gestalten Plattencover ...

1982–1985

Die Arbeit *Adam et Eve* (Adam und Eva, 1987) stellt einen drastischen Umbruch im Werk von Pierre et Gilles dar. Sie machen ihre erste Serie *Les Enfants des voyages* (Die Kinder der Reisen) auf den Malediven und in Sri Lanka. 1983 haben sie ihre erste Einzelausstellung in der Galerie Texbraun in Paris mit den Zyklen *Les paradis* (Die Paradiese) und *Les garçons de Paris* (Die Jungen von Paris).

1984 stellen sie bei „Ateliers 84" im ARC Musée d'Art Moderne de la Ville de Paris aus. Sie arbeiten mit zahlreichen Musikern und Sängern wie Etienne Daho, Lio, Amanda Lear und der Japanerin Sandii zusammen.

1985: erste Videoclips mit der Gruppe *Mikado.* Ausstellung in Tokio.

1986–1996

In der Galerie Samia Saouma werden *Naufragés* (Schiffbrüchige) und *Les pleureuses* (Die Weinenden) gezeigt. Pierre et Gilles beschäftigen sich mit religiösen Themen und Heiligen. Sie arbeiten mit Tomah, einem jungen Laoten, zusammen, der für zehn Jahre ihr Stylist und Assistent wird.

1989 beginnt ihre Freundschaft mit Marc Almond, mit dem sie ein Video drehen. Seit 1990 leben und arbeiten die Künstler in Pré-Saint-Gervais. Das Atelier und die Wohnung sind ihr ureigenes Universum, die Ansammlung verschiedenster Objekte ist für sie eine ständige Inspirationsquelle.

Pierre et Gilles unternehmen viele Reisen nach Asien. 1992 haben sie eine Ausstellung im Diaghilew-Museum für Moderne Kunst in Sankt Petersburg und 1995 eine in Moskau. 1993 werden sie mit dem Grand Prix de la Photographie de Paris ausgezeichnet. 1994 realisieren sie die Serien *Au bord du Mékong* (Am Ufer des Mekong) in Laos und *Boxeurs Thai* (Thai-Boxer) in Bangkok. 1995 stellen sie in der Roslyn Oxley9 Gallery in Sydney aus und entwerfen das Plakat für den dortigen „Schwulen und lesbischen Karneval"; sie arbeiten an *Jolis voyous* (Hübsche Taugenichtse) und *Les plaisirs de la forêt* (Die Freuden im Wald). 1996 richtet die Maison Européenne de la Photographie in Paris die erste Retrospektive für Pierre et Gilles aus, bei der sie für jedes der ausgewählten Themen eine andere Dekoration entwerfen; die Ausstellung wird ein großer Publikumserfolg. Der von Bernard Marcadé und Dan Cameron herausgegebene und von TASCHEN verlegte Katalog wird zu einem internationalen Referenzbuch.

1997–1999

1998 widmet ihnen das Museo des Bellas Artes in Valencia eine Retrospektive, im Dezember haben Pierre et Gilles mit *Douce Violence* (Sanfte Gewalt) ihre erste Ausstellung in der Galerie Jérôme de Noirmont in Paris, die sie von nun an exklusiv repräsentiert. 1999 nehmen sie an der Ausstellung *Rosso Vivo* im Padiglione d'Arte Moderna in Mailand teil und zeigen eine Retrospektive ihrer Arbeiten in Turku, Finnland.

2000

Das Jahr 2000 ist für Pierre et Gilles besonders ereignisreich. Eine wichtige Schau wird ihnen im Zentrum der Ausstellung *Appearance* in Bologna eingerichtet, und sie sind zu der großen Ausstellung *La Beauté* in Avignon eingeladen, wo sie eine Installation ihrer Arbeit *Radha et Krishna* präsentieren.

Außerdem gibt es Retrospektiven im New Yorker New Museum und im Yerba Buena Center for the Arts in San Francisco, wo sie vom amerikanischen Publikum begeistert gefeiert werden.

2001–2005

Am 9. November 2001 eröffnen Pierre et Gilles *Arrache mon cœur* (Reiße mein Herz heraus), ihre zweite Solo-Ausstellung in der Galerie Jérôme de Noirmont; diese Ausstellung geht 2002 an das KunstHaus in Wien. Ende 2002 erscheint die Publikation *Album Pierre et Gilles*, in der über 540 Werke veröffentlicht sind.

2004 präsentieren Pierre et Gilles ihre erste Retrospektive in Asien: *Beautiful Dragon* wird zuerst im Seoul Museum of Art in Korea und danach im Singapore Art Museum in Singapur gezeigt. Am 24. September wird *Le Grand Amour* (Die große Liebe), ihre dritte Einzelausstellung in der Galerie Jérôme de Noirmont, eingerichtet.

PIERRE ET GILLES
Biographie

Pierre est né à La Roche-sur-Yon en 1950, Gilles au Havre en 1953. Au début des années soixante-dix, Gilles passe son diplôme à l'école des Beaux-Arts du Havre, tandis que Pierre étudie la photographie à Genève. En 1973, Gilles correspond pendant un an avec Annette Messager, s'installe à Paris ; il fait de la peinture, des collages, collectionne les photomatons et réalise des illustrations pour les magazines et la publicité. Après l'armée en 1973, Pierre commence à travailler à Paris comme photographe pour les magazines *Rock & Folk*, *Dépêche Mode* et *Interview*.

1976–1981

À l'automne 1976, Pierre et Gilles se rencontrent lors de l'inauguration de la boutique Kenzo à Paris et commencent à vivre ensemble. Leur appartement-atelier se situe rue des Blancs-Manteaux à Paris. Dès 1977, le fait de travailler en collaboration s'impose à eux comme une évidence : Pierre fera les prises de vue et Gilles la peinture, et chacun interviendra sur le travail de l'autre.

Leurs images pour le journal *Façade* les fait connaître du public. Ils photographient Andy Warhol, Salvador Dalí, Mick Jagger, Yves Saint Laurent et Iggy Pop. Première série des *Grimaces* avec leurs amis comme modèles. 1978 marque le début de l'époque du *Palace* pour lequel ils réalisent des affiches et des cartons d'invitation... En 1979, ils emménagent dans le quartier de la Bastille. Ils font leur premier voyage en Inde. Ils travaillent pour Thierry Mugler, réalisent des pochettes de disques...

1982–1985

La réalisation d'*Adam et Ève* en 1982 marque un véritable tournant dans leur travail. Ils créent leur première série aux Maldives et, au Sri Lanka, *Les enfants des voyages*. En 1983, première exposition personnelle à la galerie Texbraun à Paris avec *Les paradis* et *Les garçons de Paris*.

En 1984, ils exposent aux « Ateliers 84 » à l'ARC Musée d'Art Moderne de la Ville de Paris. Nombreuses collaborations avec des musiciens ou chanteurs : Étienne Daho, Lio, Amanda Lear, la Japonaise Sandii.

1985 : premiers clips avec le groupe Mikado. Exposition au Art Ginza Space de Tokyo.

1986–1996

Exposition des *Naufragés* et des *Pleureuses* en 1986 à la Galerie Samia Saouma à Paris. Ils abordent les thèmes religieux et les saints. Ils travaillent avec Tomah, un jeune Laotien qui sera leur styliste et assistant pendant 10 ans.

1989 marque le début de leur amitié avec Marc Almond avec qui ils réaliseront une vidéo. Depuis 1990, ils résident et travaillent au Pré-Saint-Gervais. L'atelier et le studio sont à l'image de leur univers,

l'accumulation des objets est une source permanente d'inspiration.

Ils effectuent de nombreux voyages en Asie. Ils exposent en 1992 au musée d'Art moderne Diaghilev de Saint-Pétersbourg et à Moscou en 1995. En 1993, ils reçoivent le grand prix de Photographie de Paris. En 1994, Ils réalisent la série *Au bord du Mékong* au Laos et les *Boxeurs Thaï* à Bangkok. En 1995, ils exposent à la galerie Roslyn Oxley9 à Sydney, réalisent l'affiche du Mardi gras « Gay & Lesbian », œuvrent sur les *Jolis voyous* et *Les plaisirs de la forêt*. En 1996, première rétrospective à la Maison Européenne de la Photographie à Paris où ils y conçoivent une scénographie différente selon les thèmes choisis, cette exposition obtient un grand succès auprès du public. Le catalogue, publié par TASCHEN, édité par Bernard Marcadé et Dan Cameron devient une référence internationale.

1997–1999

En 1998, le Museo de Bellas Artes de Valence leur consacre une rétrospective, en décembre. *Douce Violence* est leur première exposition à la Galerie Jérôme de Noirmont, à Paris, qui les représentera en exclusivité. Puis en 1999, ils participent à l'exposition *Rosso Vivo* au Padiglione d'Arte Moderna de Milan et présentent également une rétrospective de leurs œuvres au Turun Taidemuseo de Turku en Finlande.

2000

L'an 2000 est pour eux une année riche en événements. Une place importante leur est consacrée au sein de l'exposition *Appearance* à Bologne et ils participent à la grande exposition *La Beauté*, en Avignon, pour laquelle ils présentent une installation avec les œuvres *Radha et Krishna*.

Puis c'est la consécration lors de leur rétrospective au New Museum de New York et au Yerba Buena Center for the Arts de San Francisco où les Américains leur font un triomphe. Ils rencontrent Kenneth Anger et James Bidgood avec lesquels ils entretiennent une grande amitié.

2001–2005

À partir du 9 novembre 2001, *Arrache mon cœur* est leur seconde exposition personnelle à la Galerie Jérôme de Noirmont ; cette exposition est ensuite présentée au KunstHaus de Vienne en 2002. Fin 2002, publication de l'*Album Pierre et Gilles*, un ouvrage regroupant plus de 540 œuvres.

En 2004, Pierre et Gilles présentent leur première rétrospective en Asie : *Beautiful Dragon* est d'abord présenté au Seoul Museum of Art (Corée) puis au Singapore Art Museum (Singapour). À partir du 24 septembre, *Le Grand Amour*, est leur troisième exposition personnelle à la Galerie Jérôme de Noirmont.

PIERRE ET GILLES

Pierre bébé, La tranche sur mer

Biographie Maritime

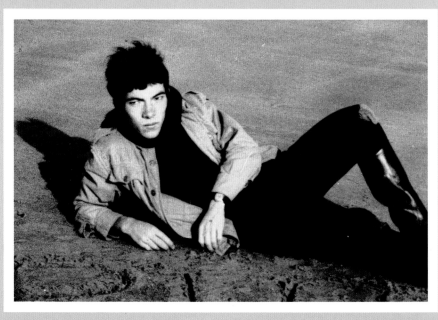

Pierre, Les Sables d'Olonne, 1970. Photo: Françoise

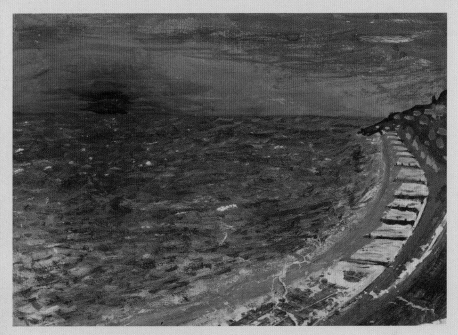

Gilles: **Soleil noir à Sainte-Adresse,** gouache sur papier, 1966

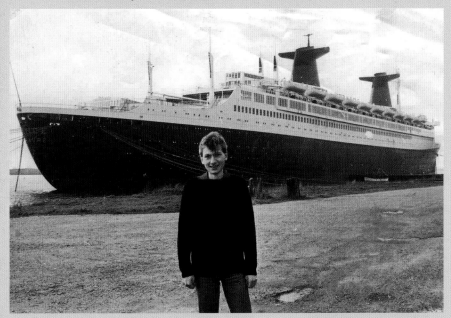

Gilles devant le *France*, Le Havre, 1976

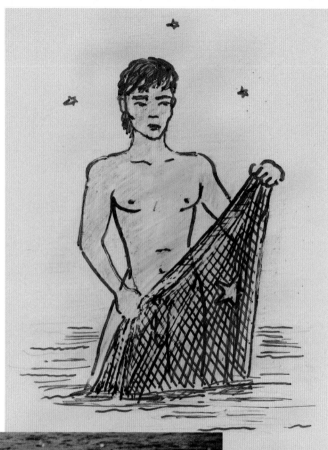

Pierre: **Le jeune pêcheur au filet,** dessin sur carton, 1996

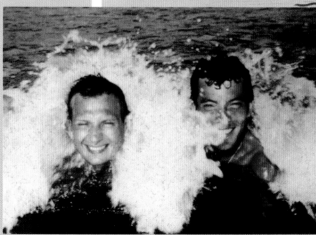

Gilles et Pierre, Tunisie, 1984
Photo: Michel Amet

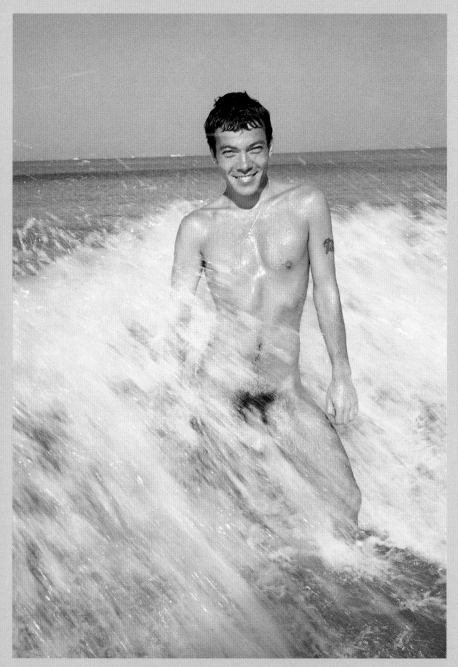

Pierre, Goa, 1982

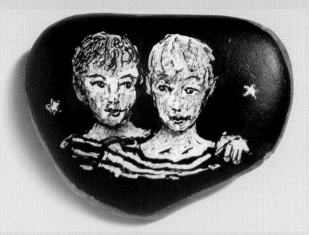

Pierre: **Pierre et Gilles,** galet peint, 2002

Figurine de marin

Gilles en marin américain, 1977. Photo: Philippe Morillon

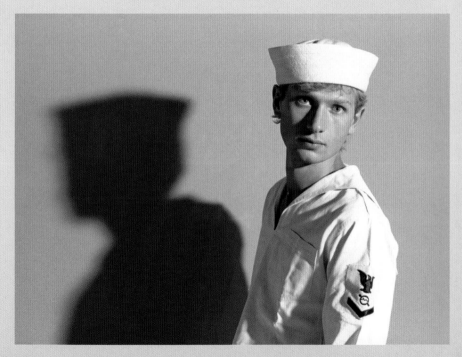

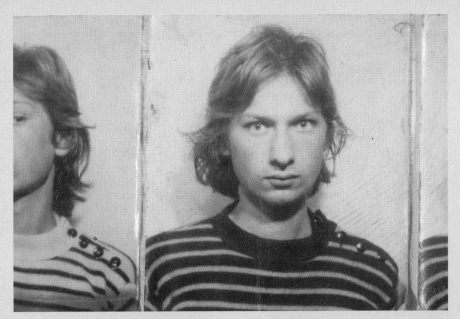

Gilles, photomatons, 1970

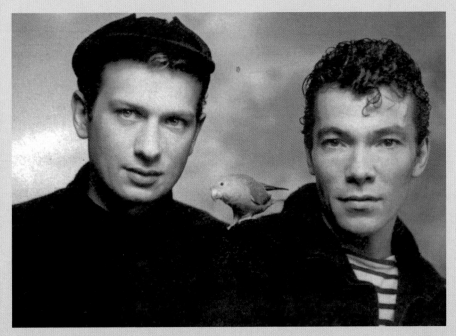

Gilles et Pierre, 1983. Photo: D.R.

Gilles: **Le pain de sucre,** acrylique sur carton, 1974

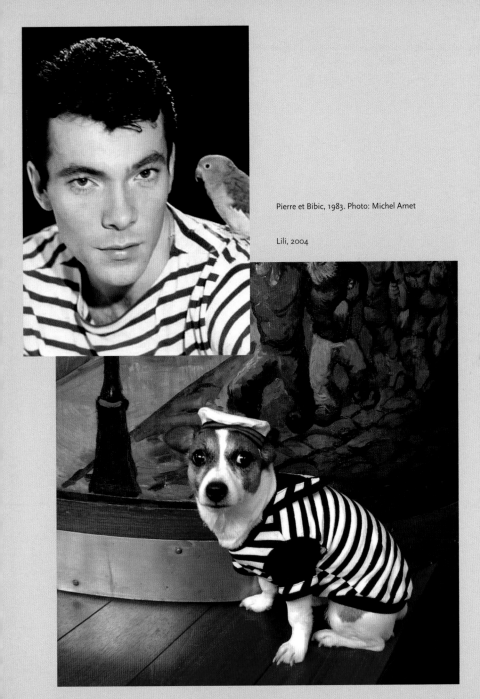

Pierre et Bibic, 1983. Photo: Michel Amet

Lili, 2004

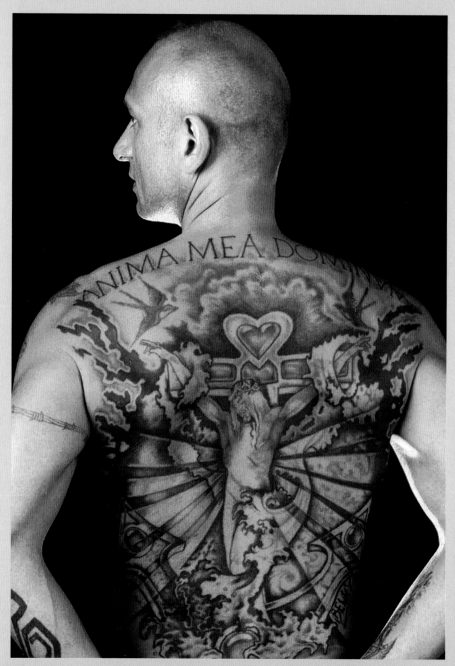

Gilles, 1999. Photo: studio *Once upon a time*, Bangkok

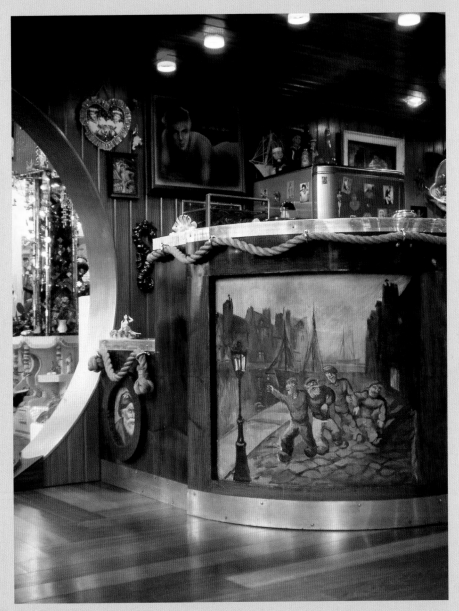

Chez Pierre et Gilles, le bar, 2004

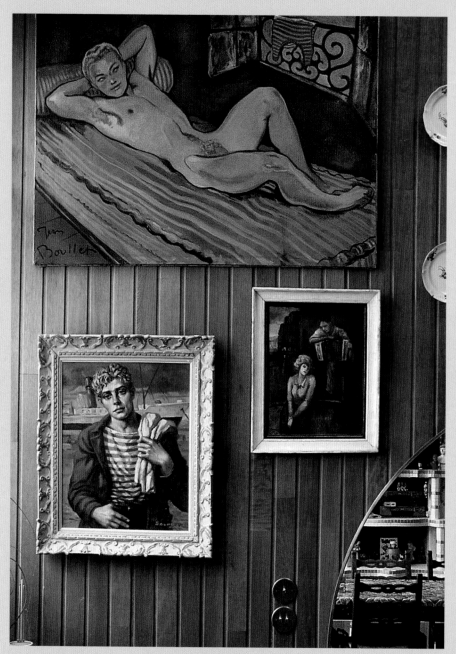

Chez Pierre et Gilles, tableaux de Jean Boullet, Pailhes et Soungouroff

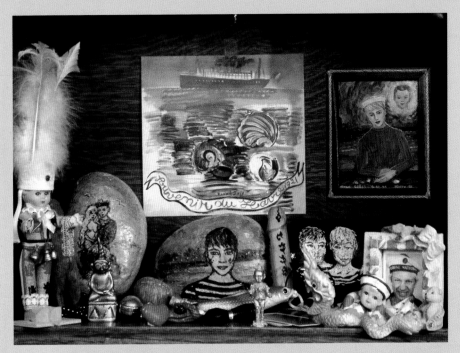

La chambre de Gilles, objets souvenirs

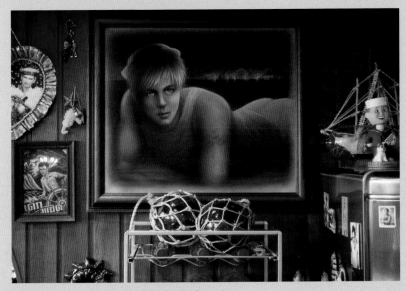

Chez Pierre et Gilles, tableau de Jonas Eduardo *Mistral's son*

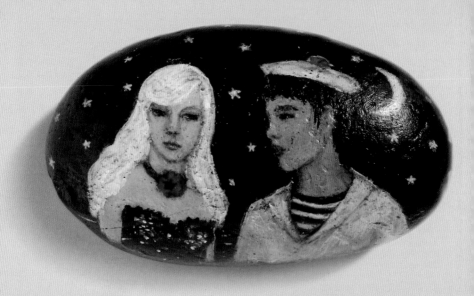

Pierre: **Ne t'en va pas,** galet peint, 2004

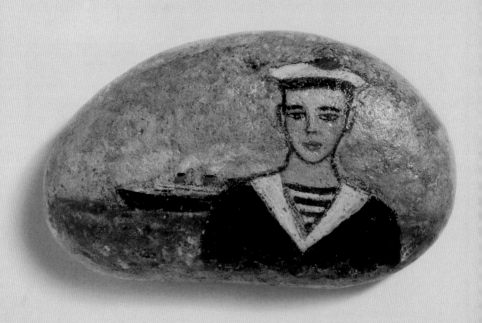

Pierre: **Le marin,** galet peint, 1999

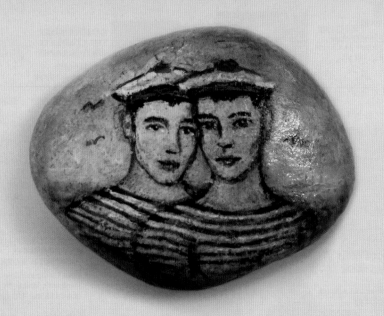

Pierre: **Les deux marins,** galet peint, 2000

Pierre: **Lili à la mer,** galet peint, 2003